DRAW 62 CHARACTERS AND MAKE THEM CUTE

STEP-BY-STEP DRAWING FOR FIGURES AND PERSONALITY

For Artists, Cartoonists, and Doodlers

HEEGYUM KIM

QUARRY

CONTENTS

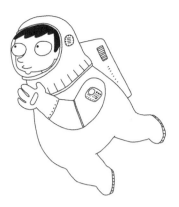

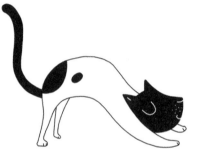

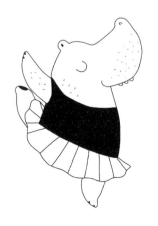

INTRODUCTION

Creating characters from your imagination is a fun way to build your drawing skills. You may have some type of character in mind, perhaps a character for a story you want to tell, or one that reminds you of a favorite friend or pet or superhero. Alternatively, perhaps your character will evolve as you are drawing and experimenting. Maybe you like some particular features of a sketch, but don't like others—so keep drawing new iterations, keeping the aspects you like, and tweaking the ones you don't. You may get ideas for characters from your stories, books, movies, cartoons, or video games. It's always helpful to approach a drawing by doing some research. Look at both historical and pop culture images, collect reference material, see how other artists have developed different characters—let all of this inspiration infuse your work.

Drawing is a wonderful activity, whether you do it for fun or as a profession. And it's good for you. Studies have actually shown that drawing improves creativity, memory, communication skills, and problem solving skills. In addition to improving physical dexterity and brain/body coordination, drawing also provides stress relief, an outlet for emotions, and increases your emotional intelligence. In my daytime job, I work as a graphic designer, but I look forward to my evenings and weekends when I spend much of the time drawing.

How to Use this Book

Use this book as a guide and reference to begin developing your own characters. On the left-hand page of each spread, follow along with the step-by-step guide for drawing the basic form.

Concentrate on the main geometric shapes that combine to make the figure. Then, add identifying features such as eyes, arms, or feet. Lastly, fill in the facial attributes that bring the character to life. Ask yourself questions about your character: What mood are they in? What activity are they doing? What are they thinking about? After you master the basic drawing of the creature, use the right-hand page to inspire further drawings of this character in various poses, with different expressions, or engaging in interesting activities. There are spaces throughout the book for you to draw, or feel free to use your favorite paper, drawing pad, or sketchbook. Tips are sprinkled throughout to share variation ideas and drawing techniques.

Experiment with a variety of drawing tools to get familiar with how they feel and the kind of marks they make. Most of the drawings here begin with pen or pencil lines. Add marker to fill in solid areas or use colored pencil for variety.

Remember, the best way to get better at drawing is to draw! Set up a regular practice or find time when you can fit it in. I hope this book provides you with loads of fun ways to expand your drawing skills and your imagination!

DRAW ALFRED
THE ALIEN

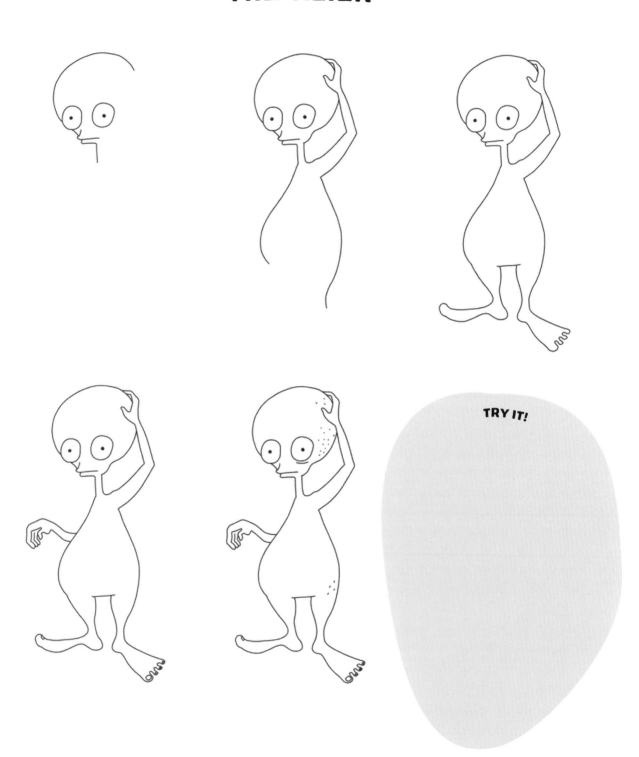

TRY IT!

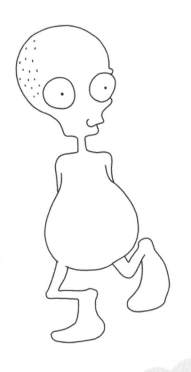

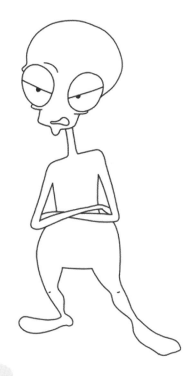

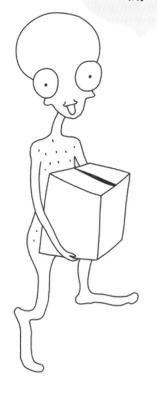

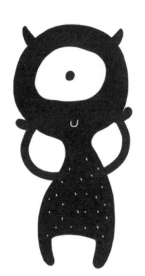

MAKE HIM CUTE

DRAW MAY
THE MILK DELIVERY GIRL

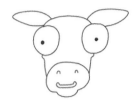 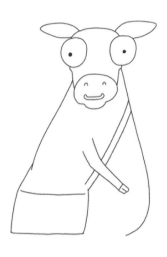 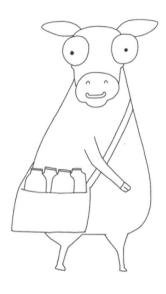

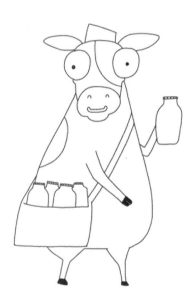 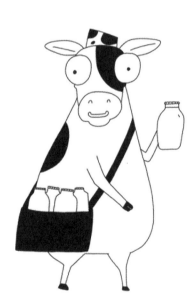 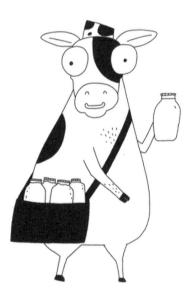

→**TIP**← Giving your character a job or activity can inform your drawing and help set creative parameters.

Would you like some fresh milk?

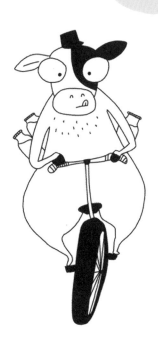

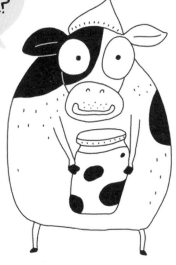

I am so done with today.

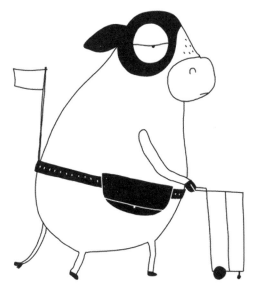

MAKE HER CUTE

DRAW DAN
THE DASHING DINOSAUR

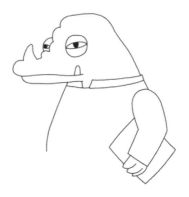

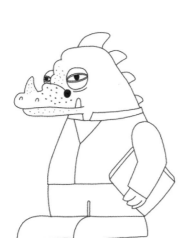

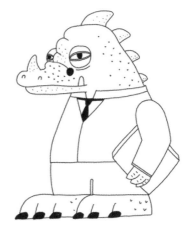

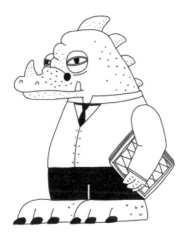

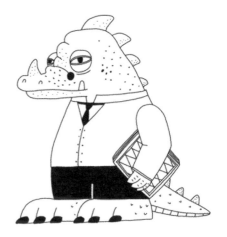

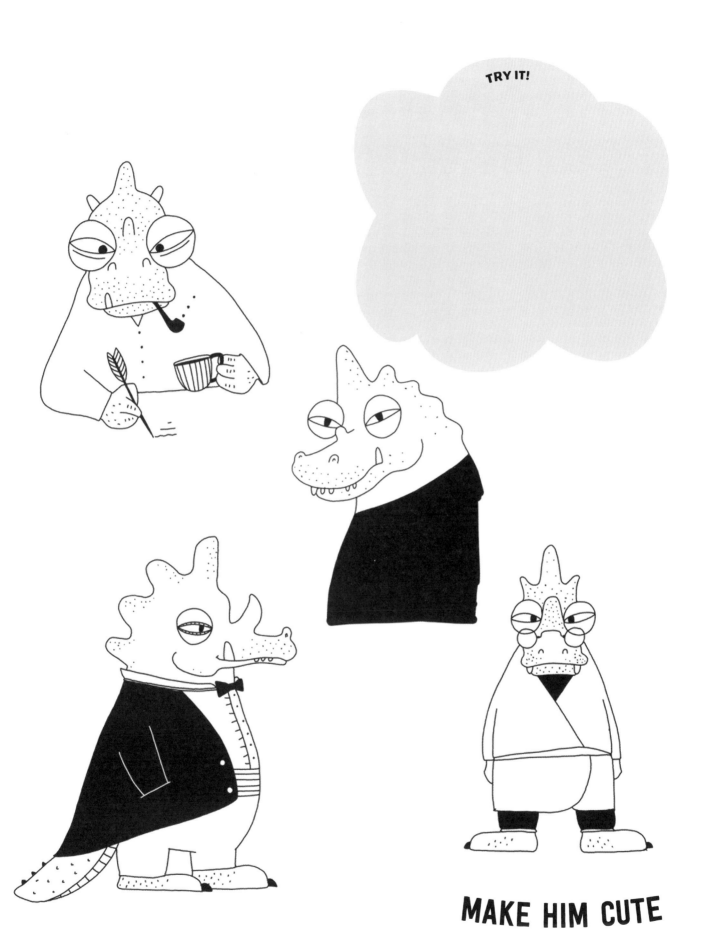

TRY IT!

MAKE HIM CUTE

DRAW EPHRAM
THE ELEPHANT PLUMBER

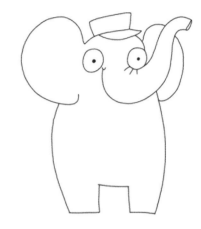

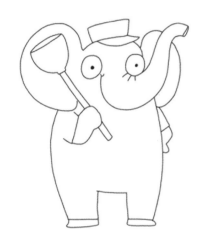
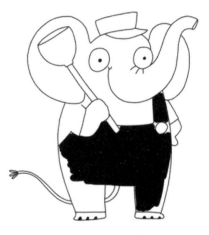

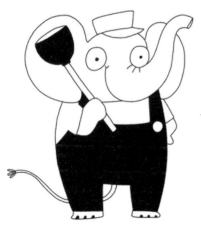
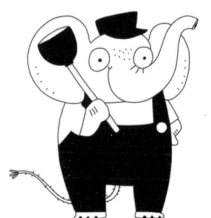

TRY IT!

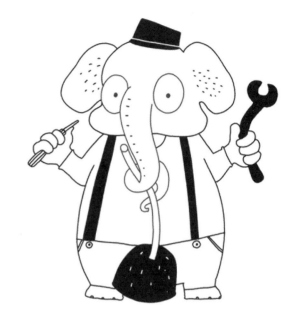

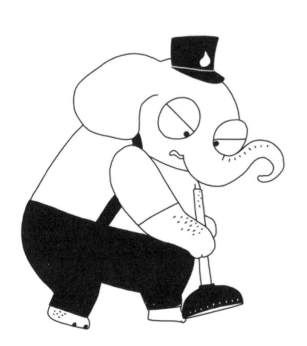

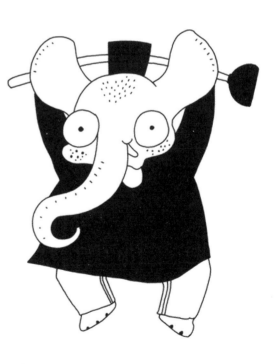

MAKE HIM CUTE

DRAW ARGO
THE WANDERING ASTRONAUT

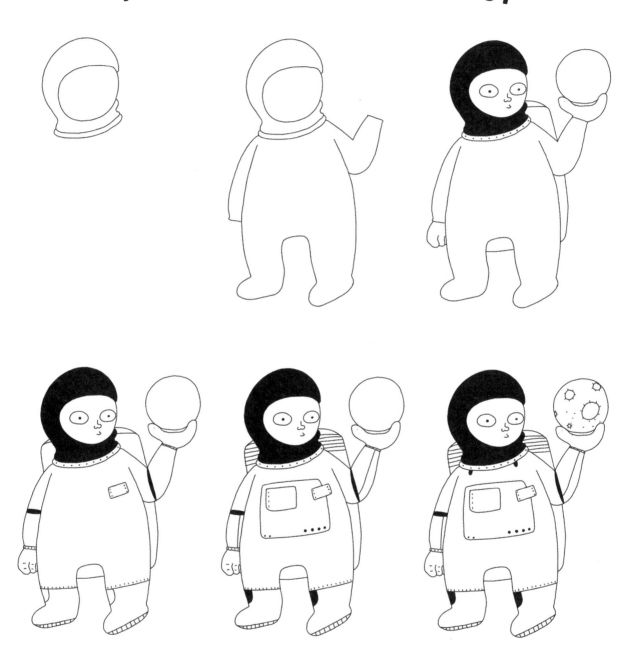

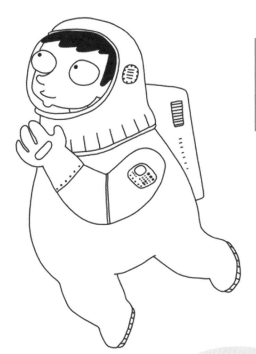

→**TIP**← Small details, such as dotted or striped lines, can add sophistication to a simple line drawing.

TRY IT!

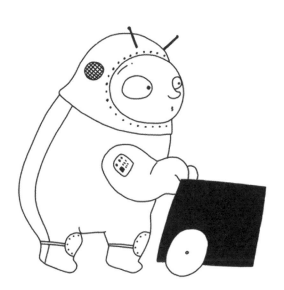

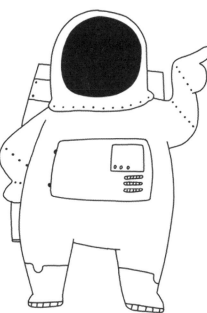

MAKE HIM CUTE

DRAW CHRISSY
THE CAT

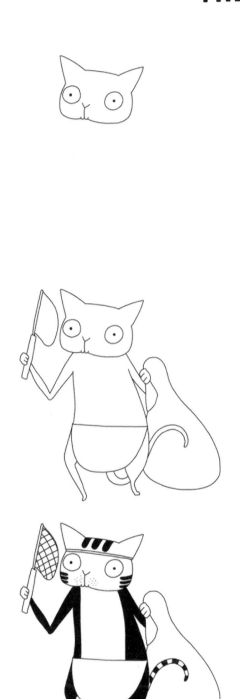
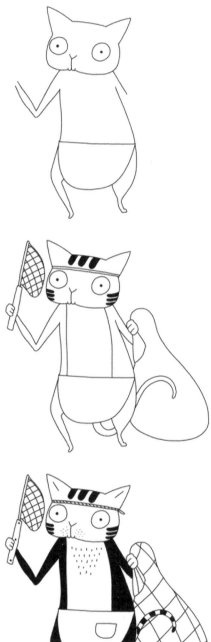
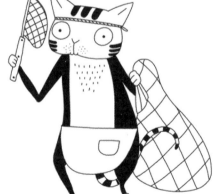

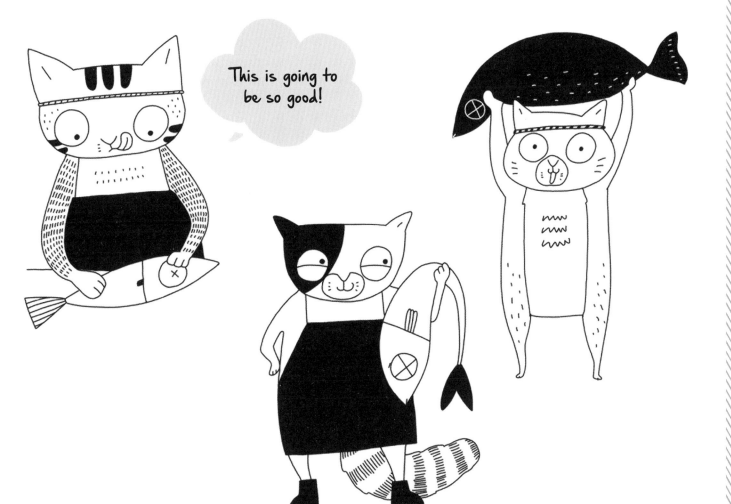

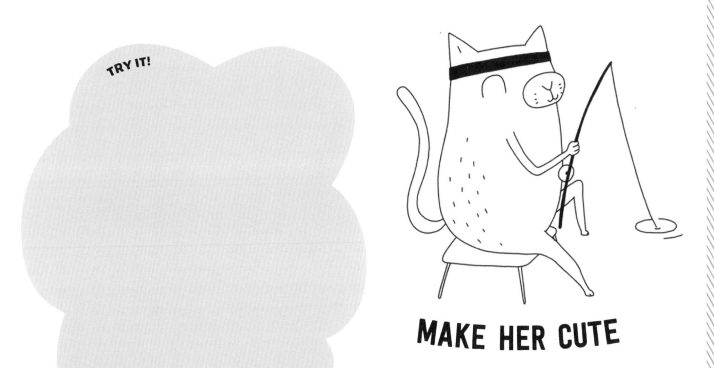

MAKE HER CUTE

DRAW HARRY
THE HIPSTER

 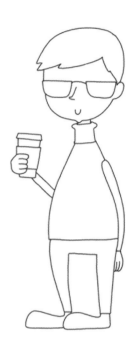

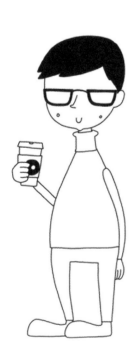 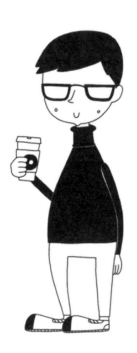 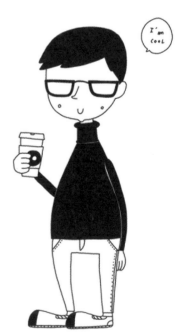

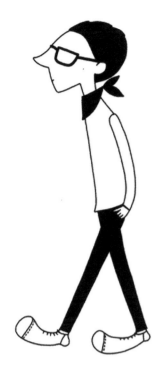

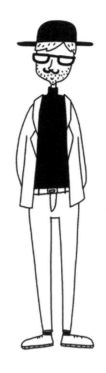

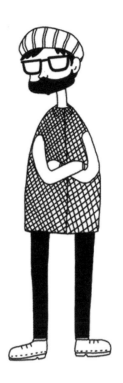

TRY IT!

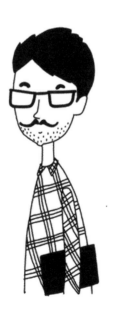

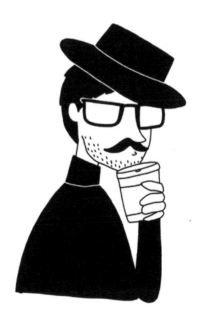

MAKE HIM CUTE

DRAW NESTOR
THE NERD

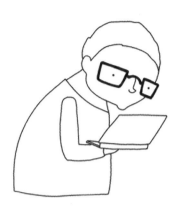
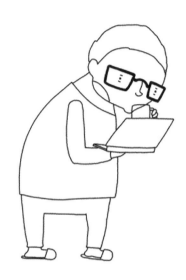

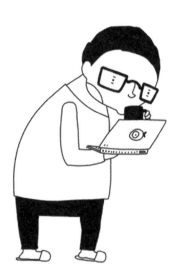
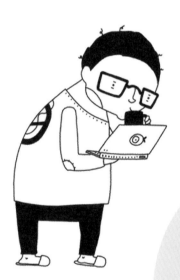

TRY IT!

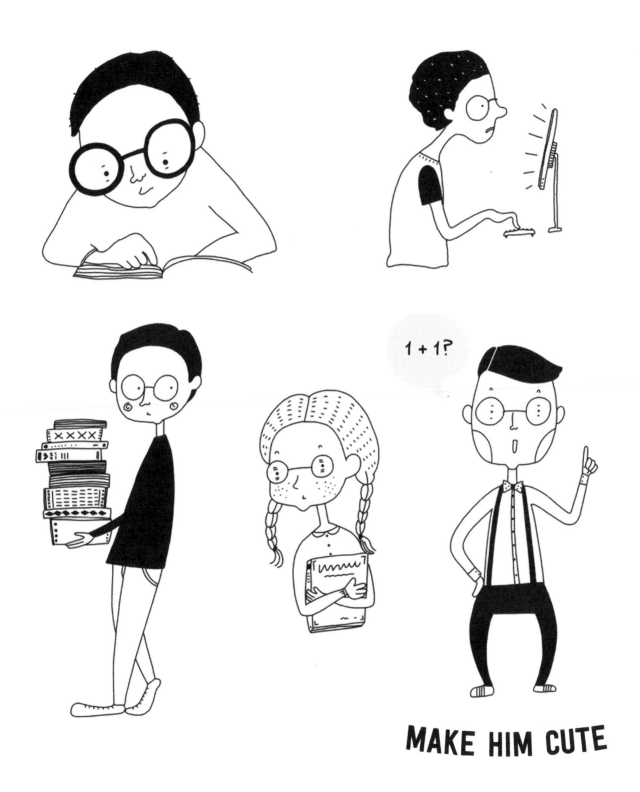

1 + 1?

MAKE HIM CUTE

DRAW SUPER SAM

 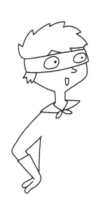 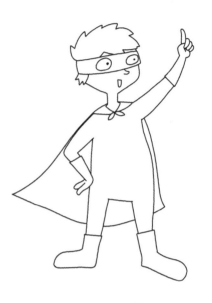

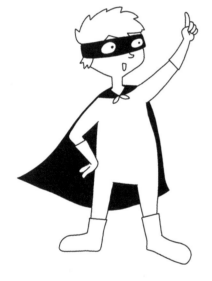 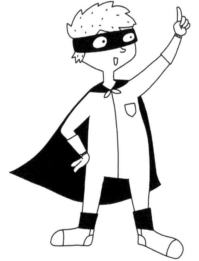

TRY IT!

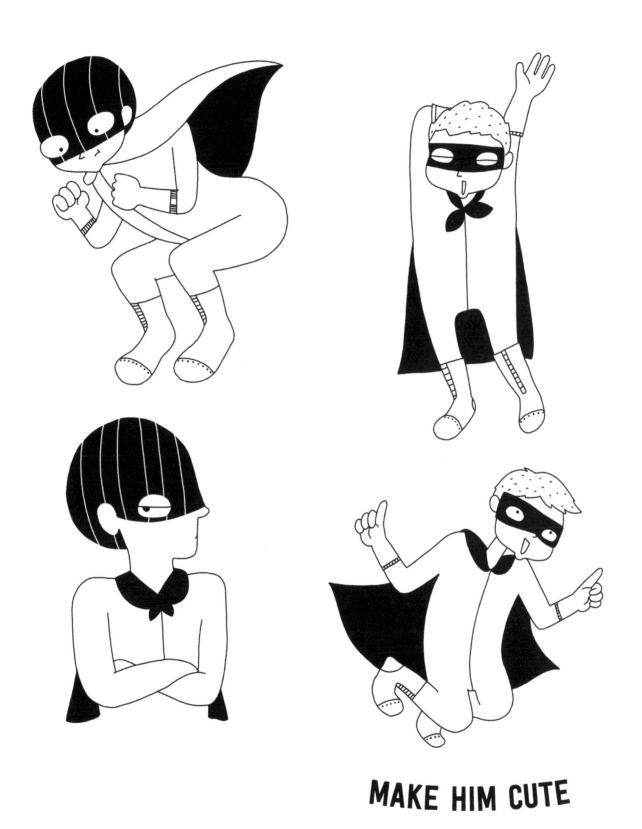

MAKE HIM CUTE

DRAW VIKRAM
THE VILLAN

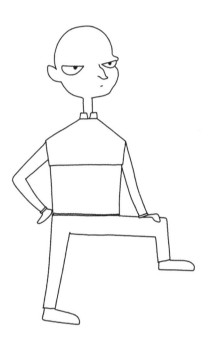

TRY IT!

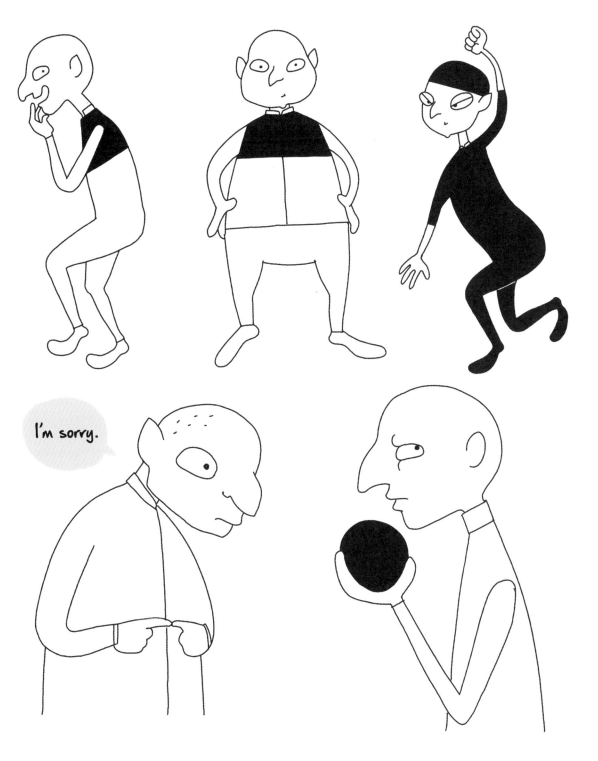

MAKE HIM CUTE

DRAW BELLA
THE BALLERINA

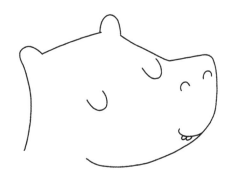

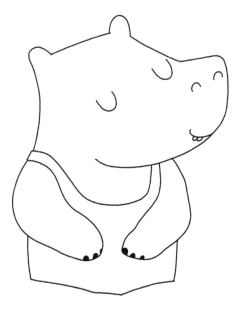

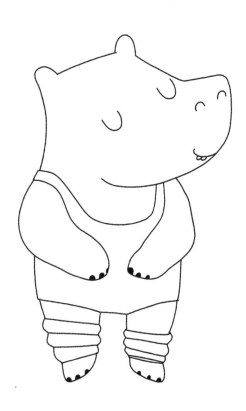

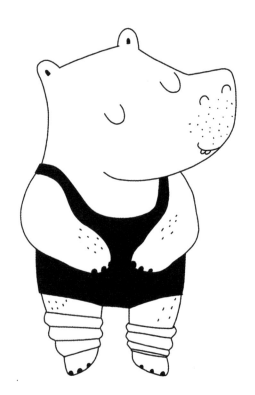

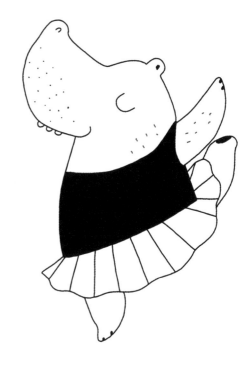

. . . and twirl!

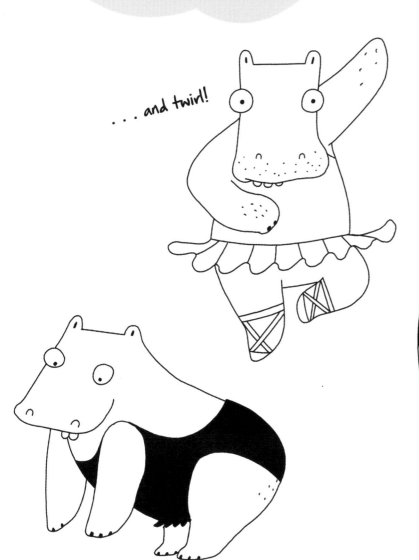

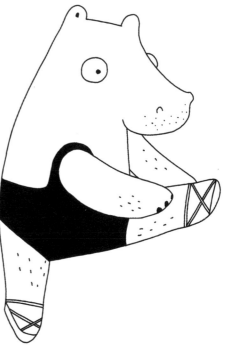

MAKE HER CUTE

DRAW YASMIN
THE YOGI KITTY

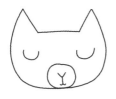

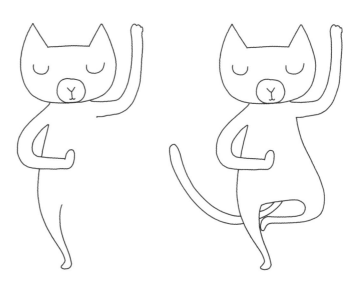

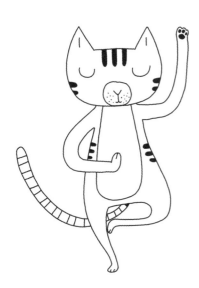

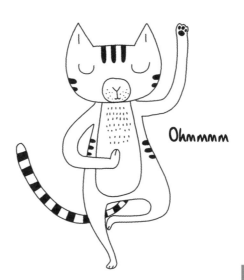

Ohmmmm

→**TIP**← There are many ways to evoke the impression of fur. A few techniques are repeated pattern lines; loose, all-over hash marks; and wavy lines.

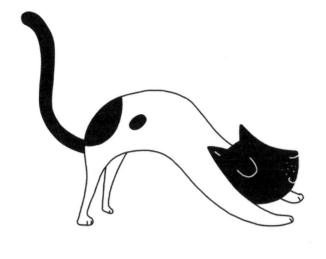

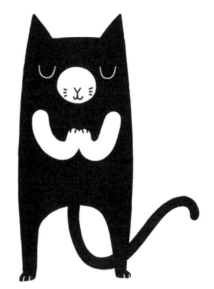

TRY IT!

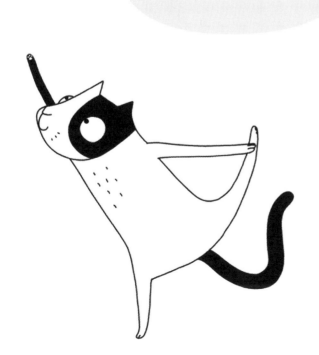

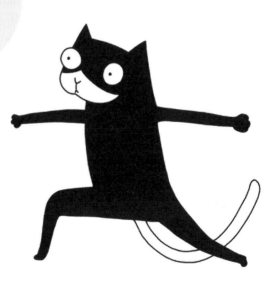

MAKE HER CUTE

DRAW BODIE
THE BOT

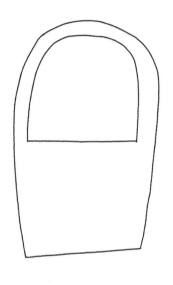

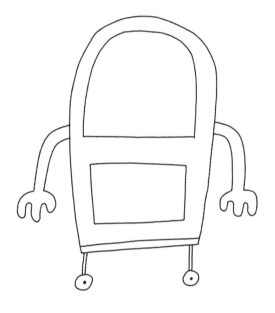

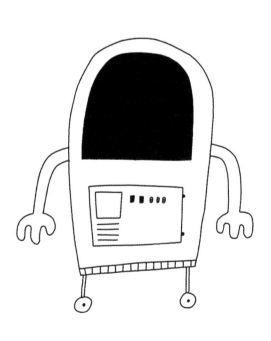

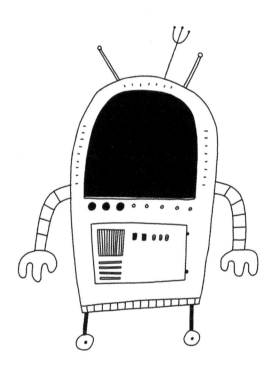

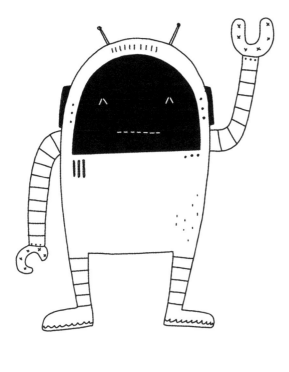

TRY IT!

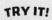

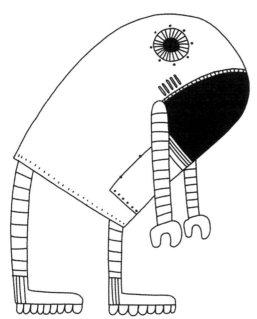

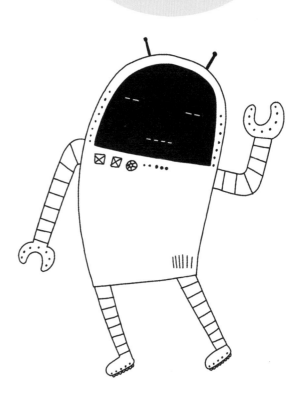

MAKE IT CUTE

DRAW WALTER
THE WHALE

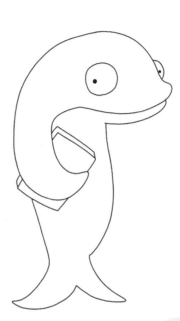

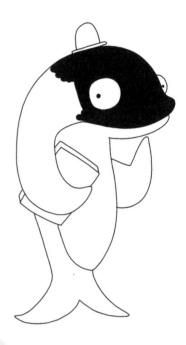

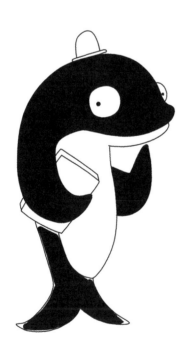

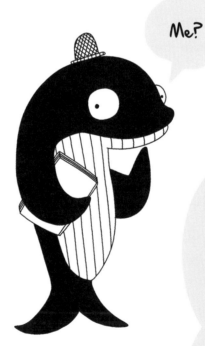

Me?

TRY IT!

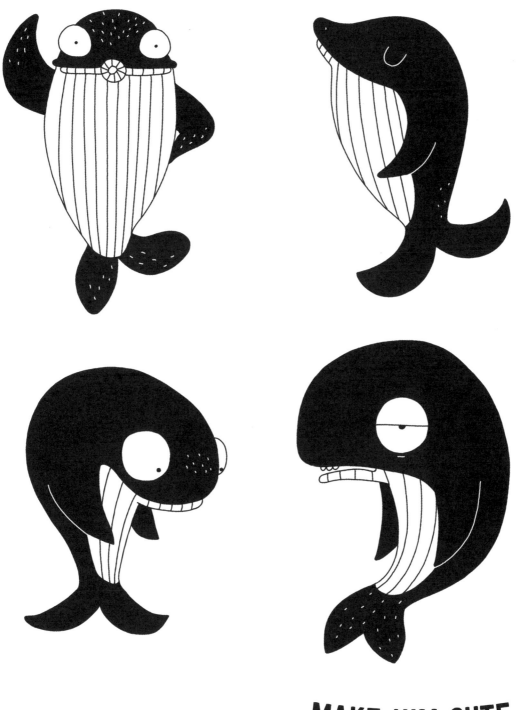

MAKE HIM CUTE

DRAW HELGA
THE FARM GIRL

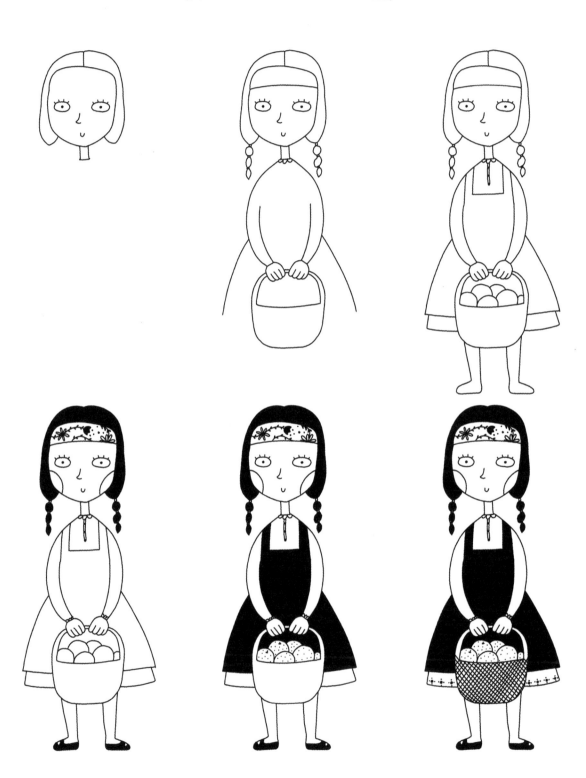

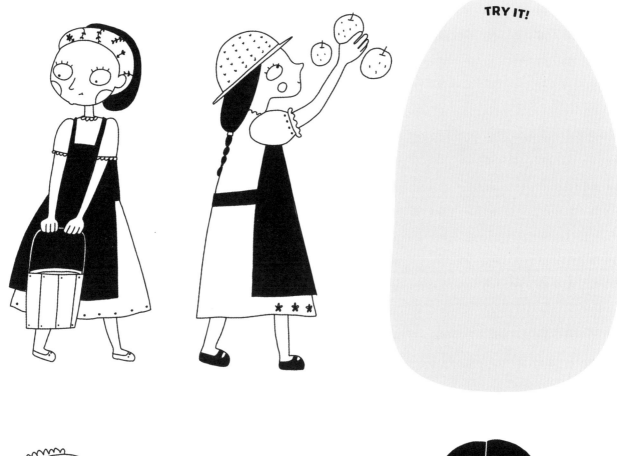

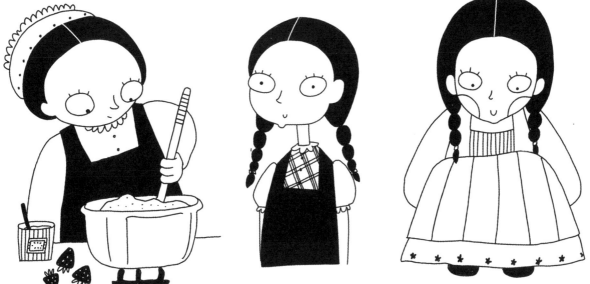

MAKE HER CUTE

DRAW MASHA
THE MAD SCIENTIST

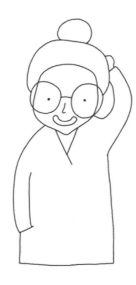
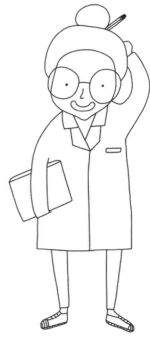

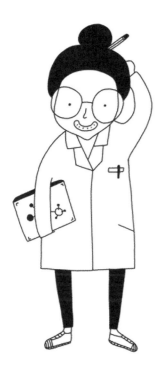

TRY IT!

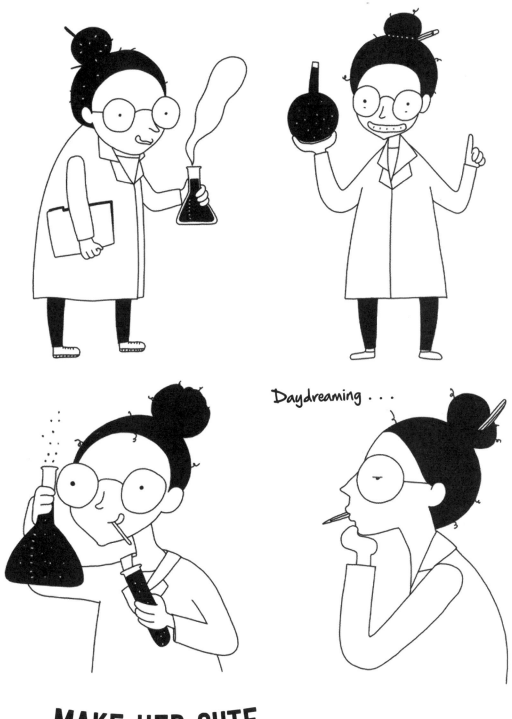

Daydreaming . . .

MAKE HER CUTE

DRAW AMIT
THE ARCHAEOLOGIST MOLE

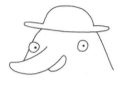 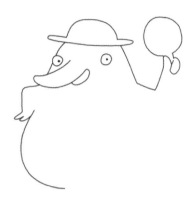 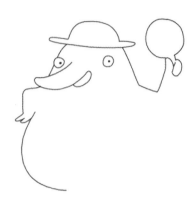

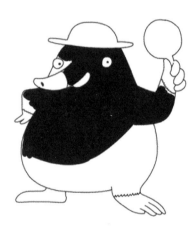 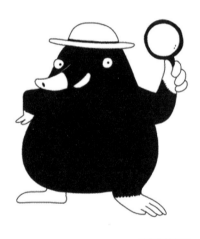 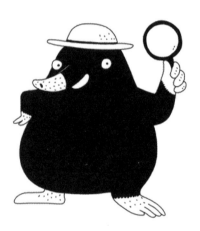

TRY IT!

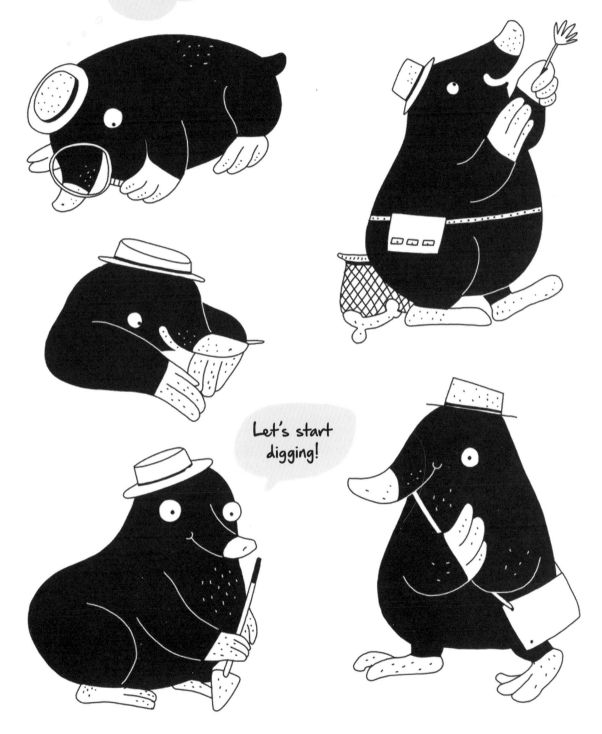

MAKE HIM CUTE

DRAW PIETRO
THE PAINTER

 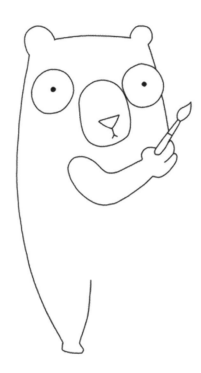 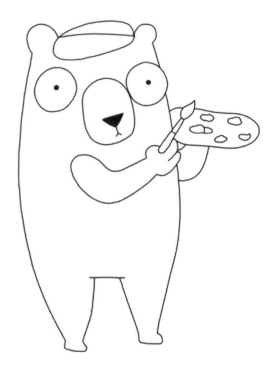

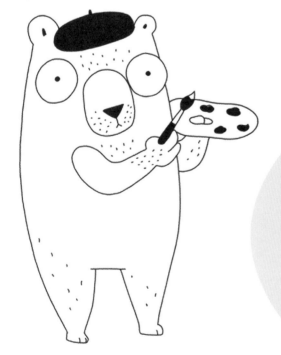

TRY IT!

Inspiration!

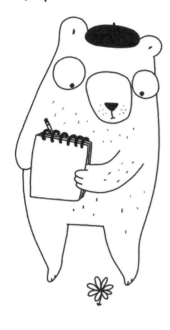

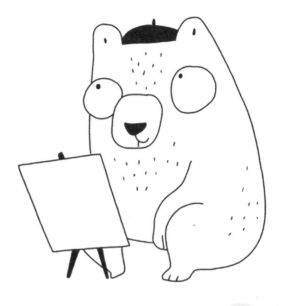

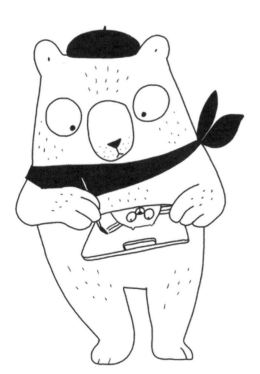

I need more coffee.

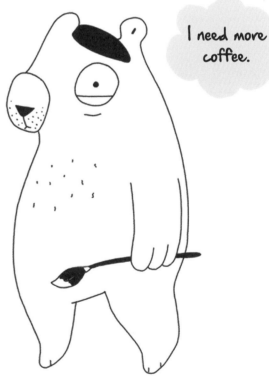

MAKE HIM CUTE

DRAW JEFF
THE FROG CHEF

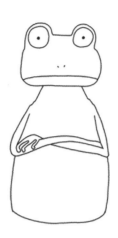

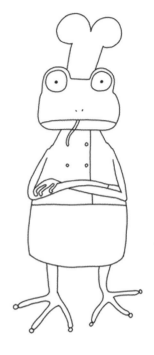

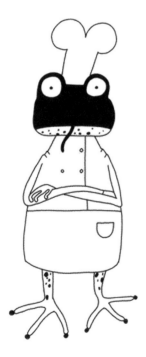

TRY IT!

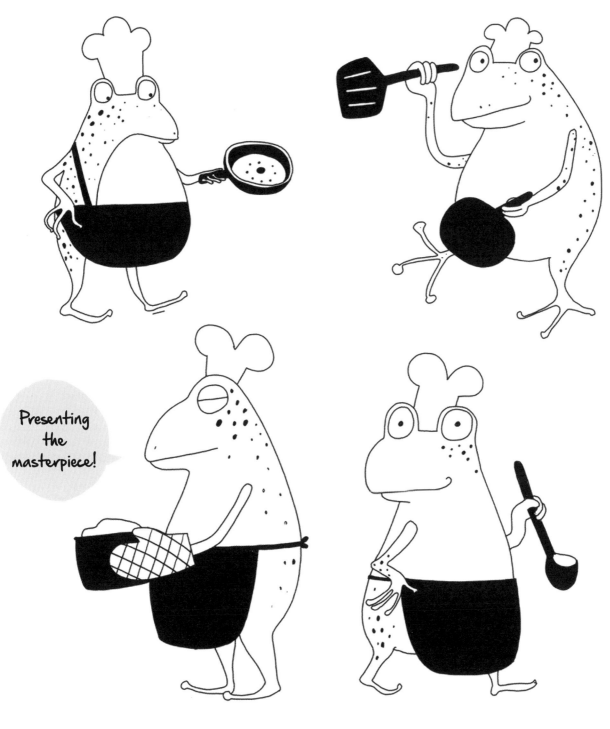

MAKE HIM CUTE

DRAW SANDRO
THE SEA SCHOLAR

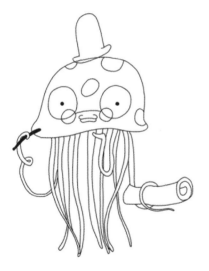

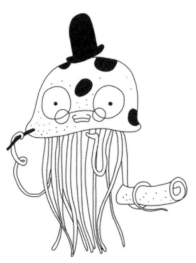

TRY IT!

I'm a professor

MAKE HIM CUTE

DRAW GILLIAN
THE LIBRARIAN

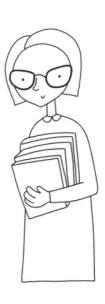

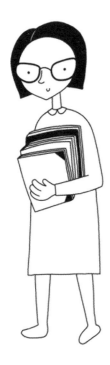
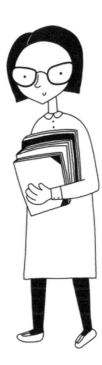
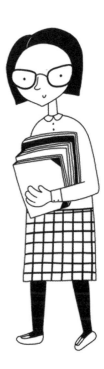

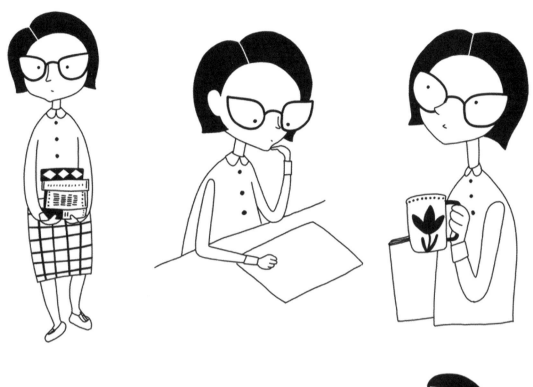

TRY IT!

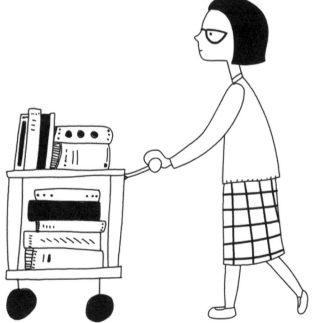

MAKE HER CUTE

DRAW BABY JESSIE

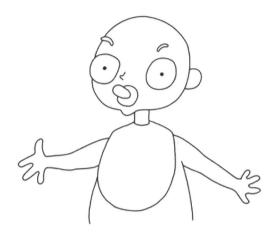

> →**TIP**← What makes babies cute? Some says it's their eyes, which are huge relative to their faces, and heads that are too big for their bodies. Play with proportion as you develop your characters.

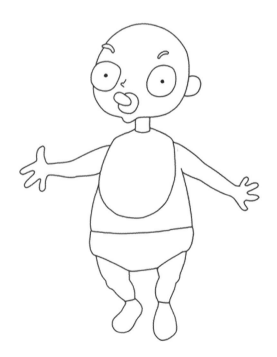

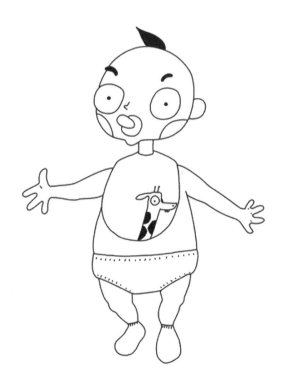

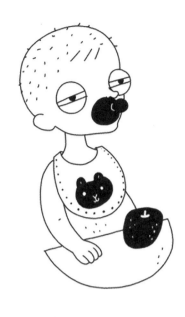

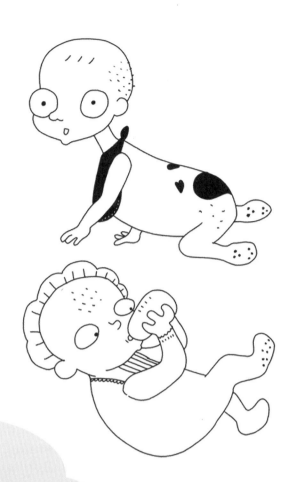

TRY IT!

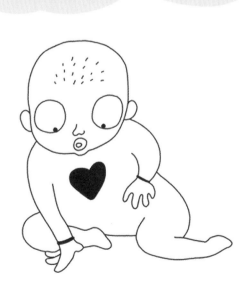

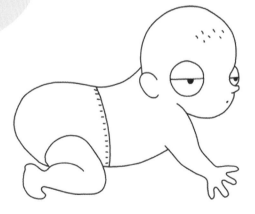

MAKE THEM CUTE

DRAW ERROL
THE EXPLORER

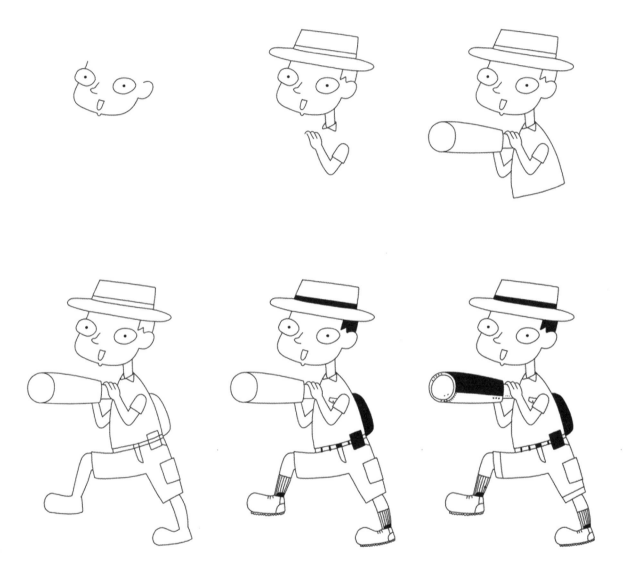

>TIP< Even loosely drawn characters can have fine features, such as a square jaw, a pointed chin, or a turned-up nose. Pay attention to precise facial characteristics, especially when you are changing their position or pose.

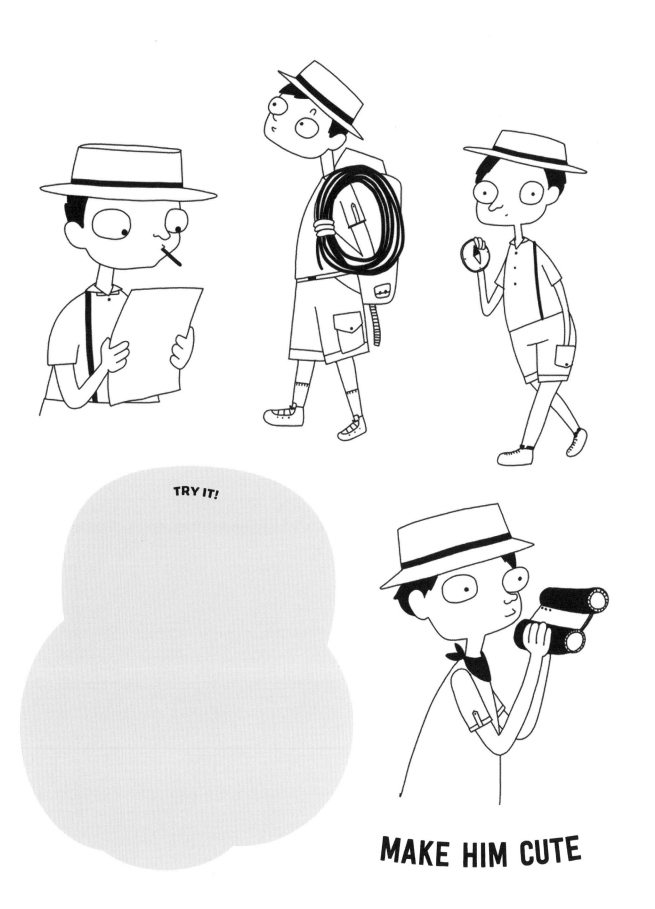

TRY IT!

MAKE HIM CUTE

DRAW FALCO
THE FEATHERED PILOT

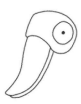 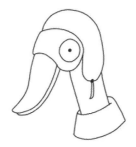 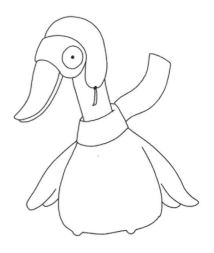

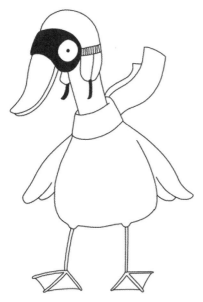 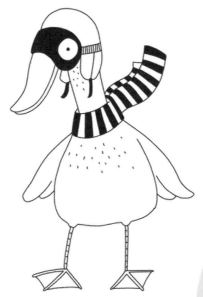

TRY IT!

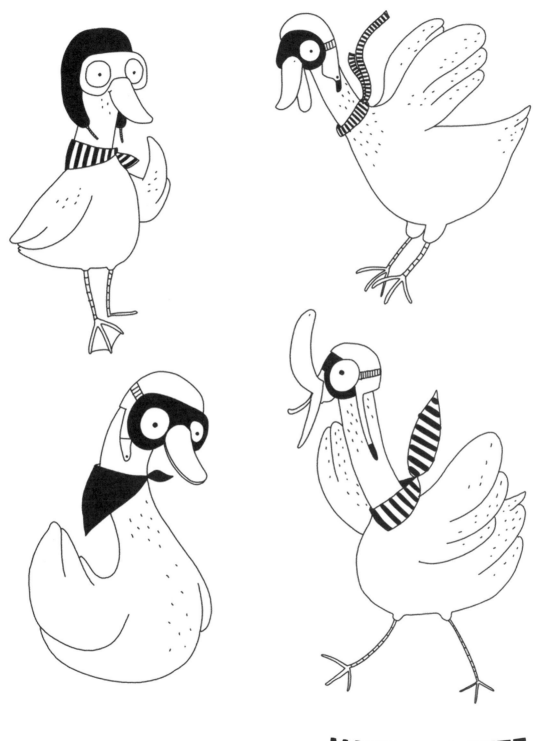

MAKE HIM CUTE

DRAW PALOMA
"THE BOSS" PIGEON

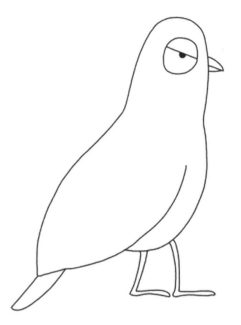

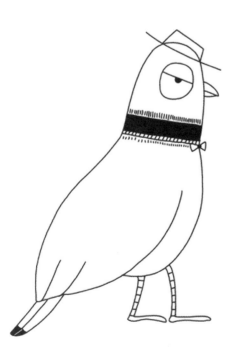

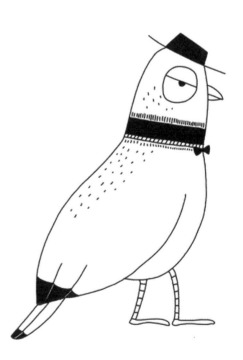

→**TIP**← How many ways can you draw feathers? Dots, ovals, "U" shapes, zig zags? Practice your creative mark making as you draw feathered friends. See another approach on pages 74 and 75.

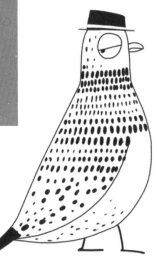

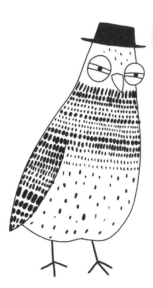

TRY IT!

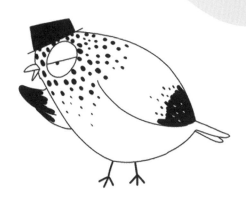

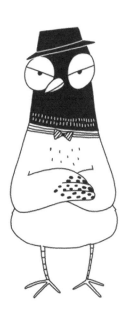

MAKE HIM CUTE

DRAW FRANNY
THE FOOD FINDER

 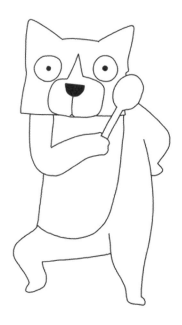

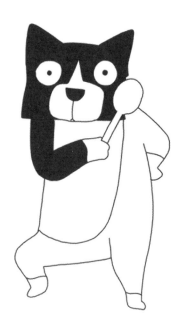 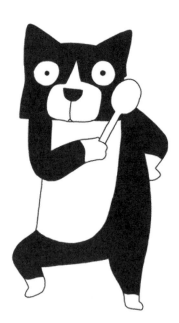 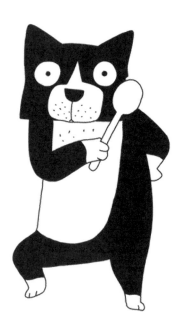

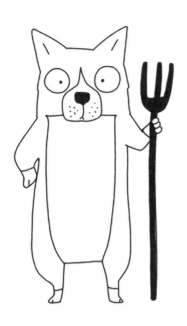
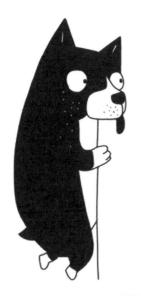
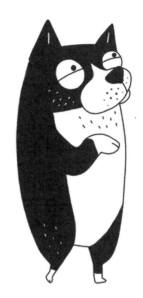

TRY IT!

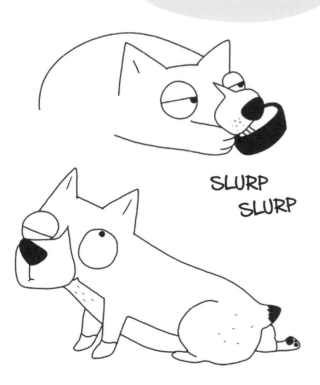

SLURP
SLURP

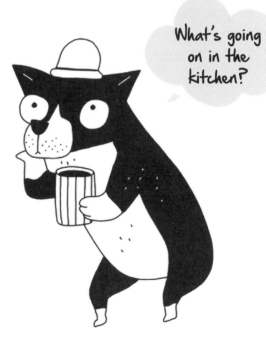

What's going on in the kitchen?

MAKE HER CUTE

DRAW PRESTON
THE PELICAN POLITICIAN

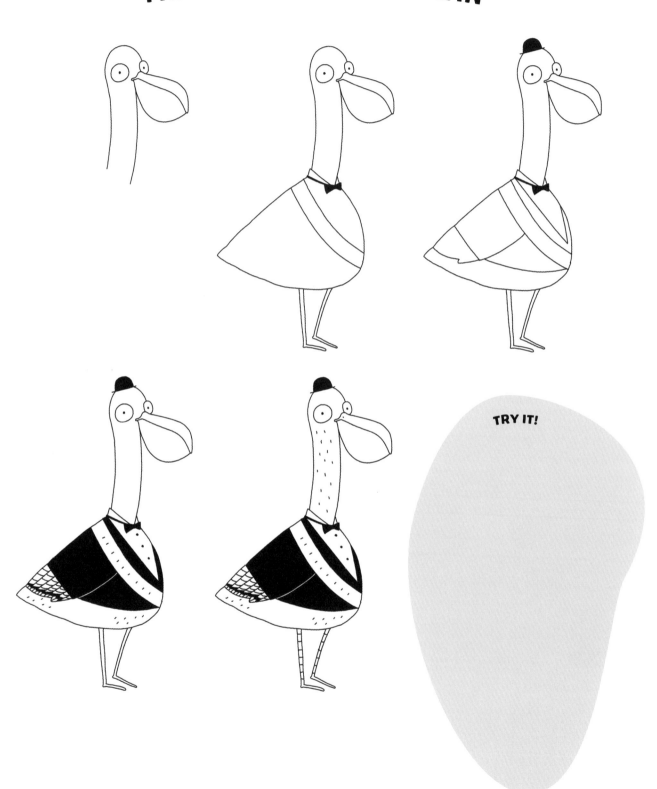

TRY IT!

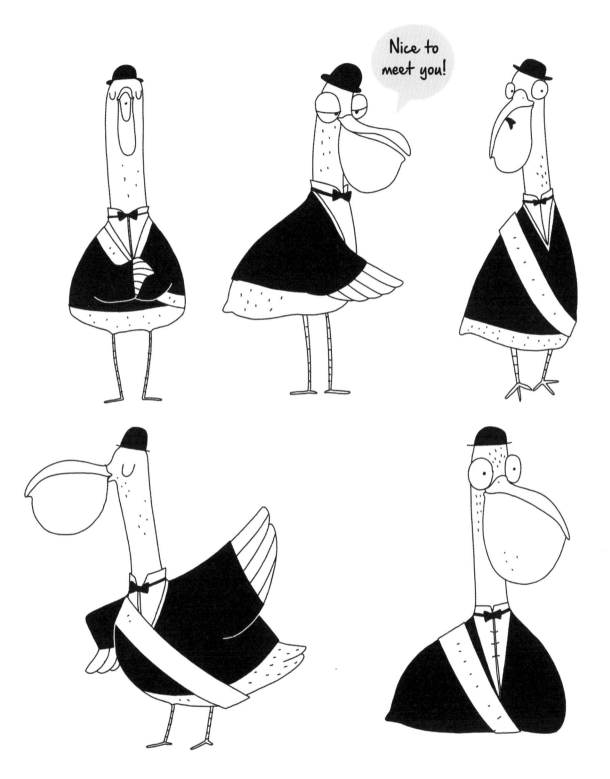

MAKE HIM CUTE

DRAW IZZY
THE ICE CREAM MAKER

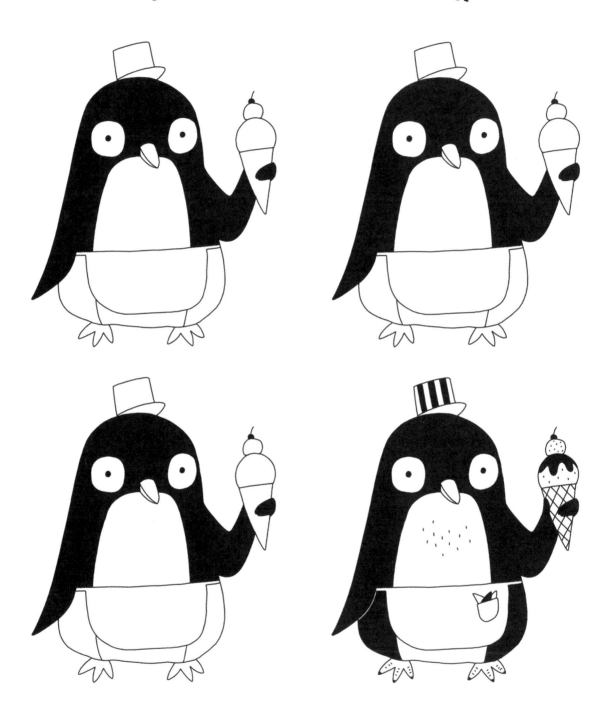

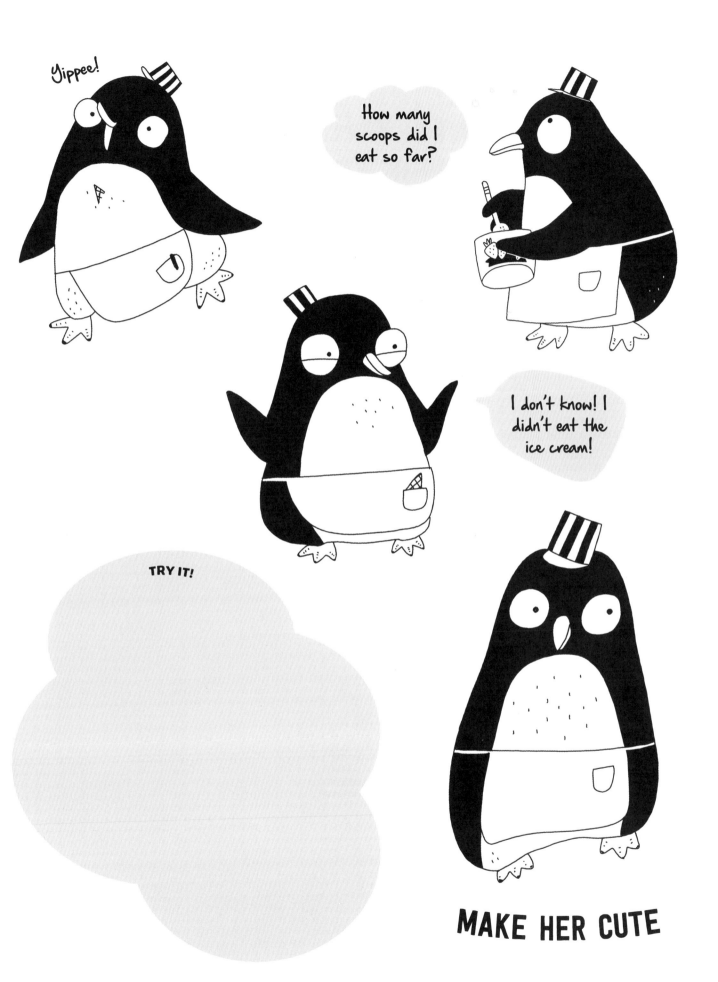

MAKE HER CUTE

DRAW JACQUES
AND HIS BAGUETTE

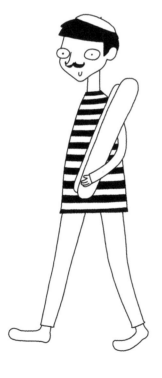

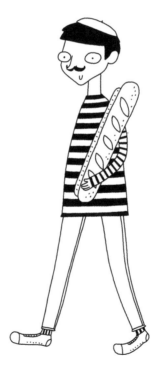

TRY IT!

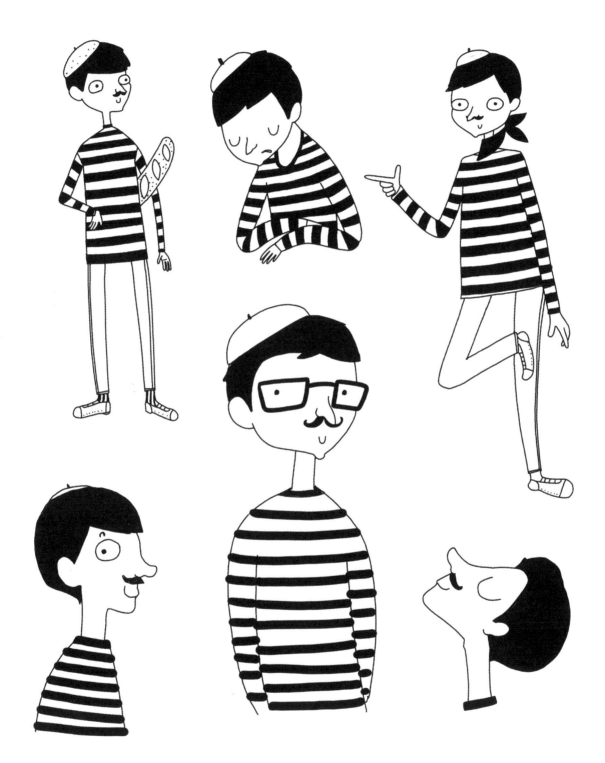

MAKE HIM CUTE

DRAW KENNY
"THE BEAR" KOALA

 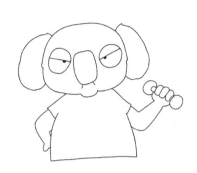 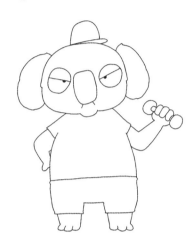

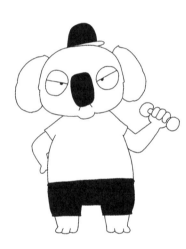 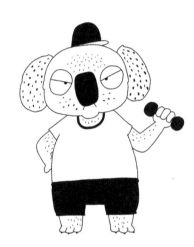 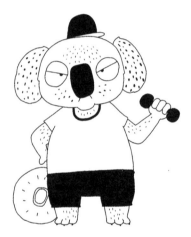

TRY IT!

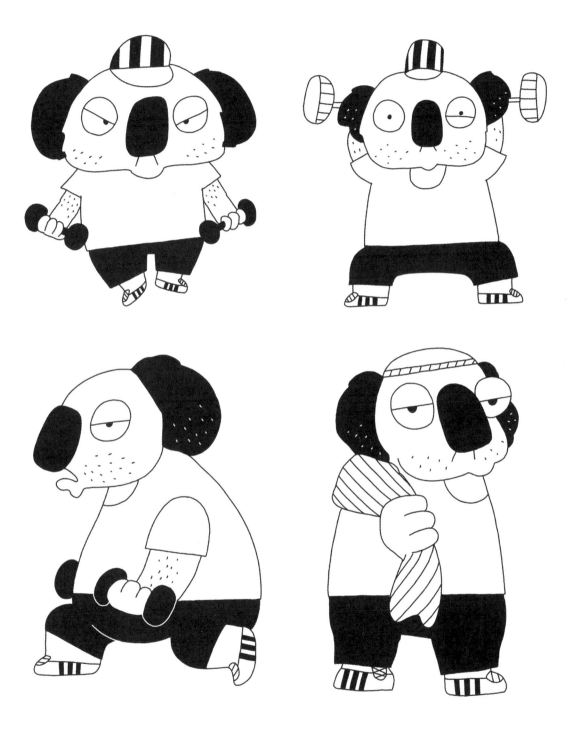

MAKE HIM CUTE

DRAW EUNICE
THE TRENDY EWE

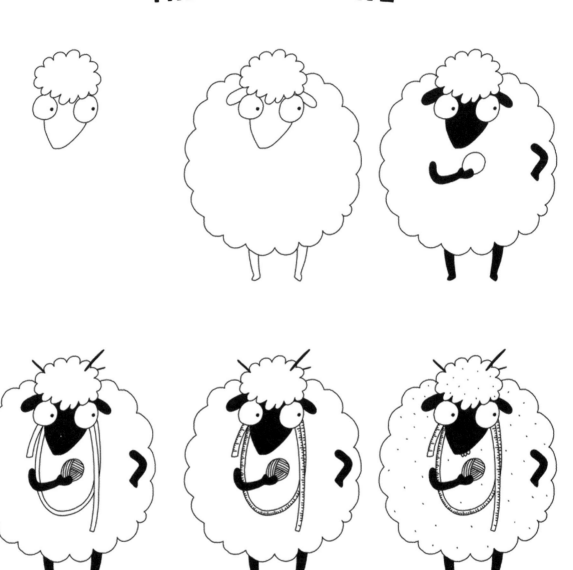

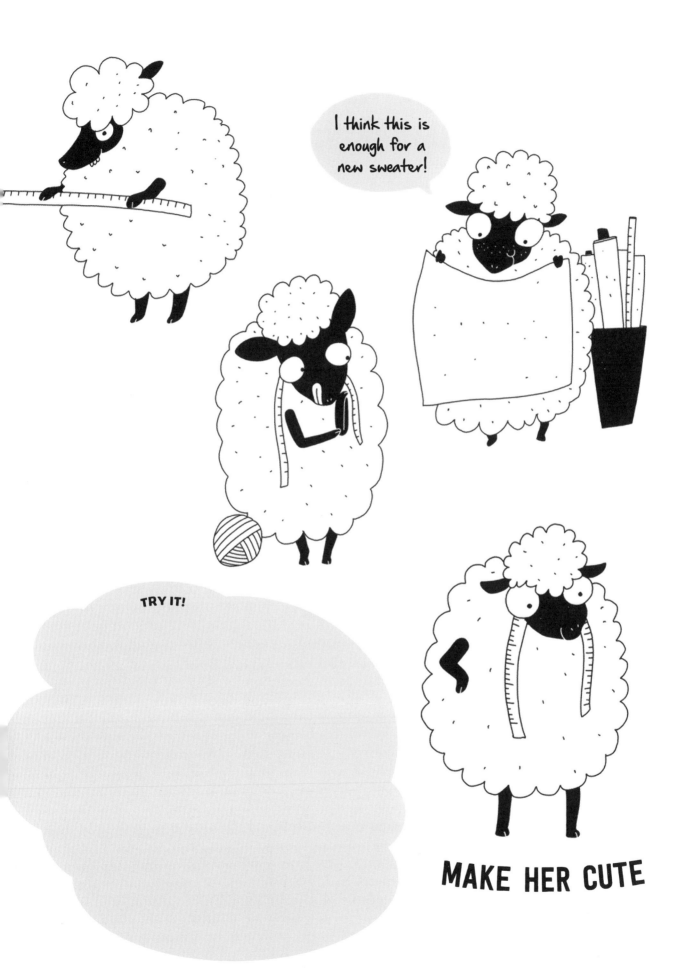

I think this is enough for a new sweater!

TRY IT!

MAKE HER CUTE

DRAW BIANCA
THE BAKING PIG

 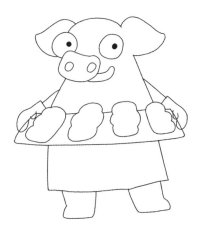

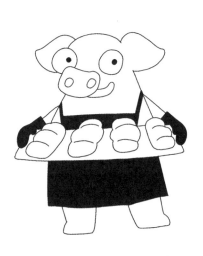 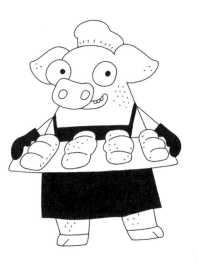

TRY IT!

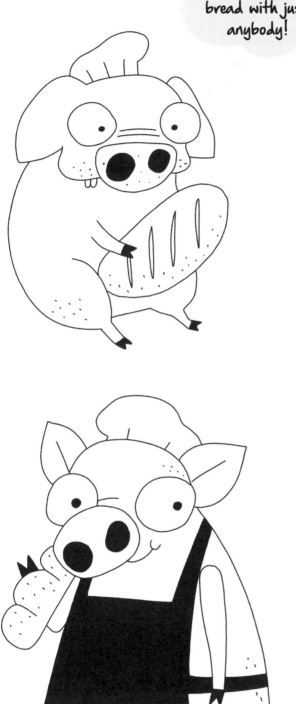

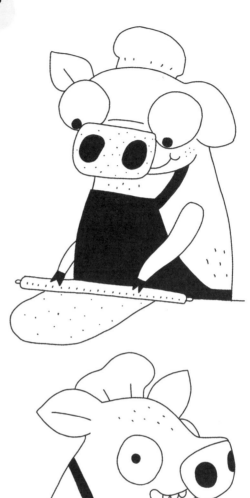

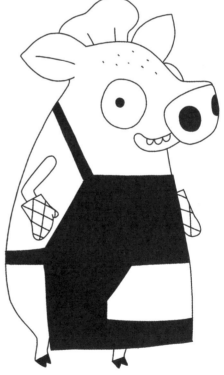

MAKE HER CUTE

DRAW DARIUS MOUSE, P.I.

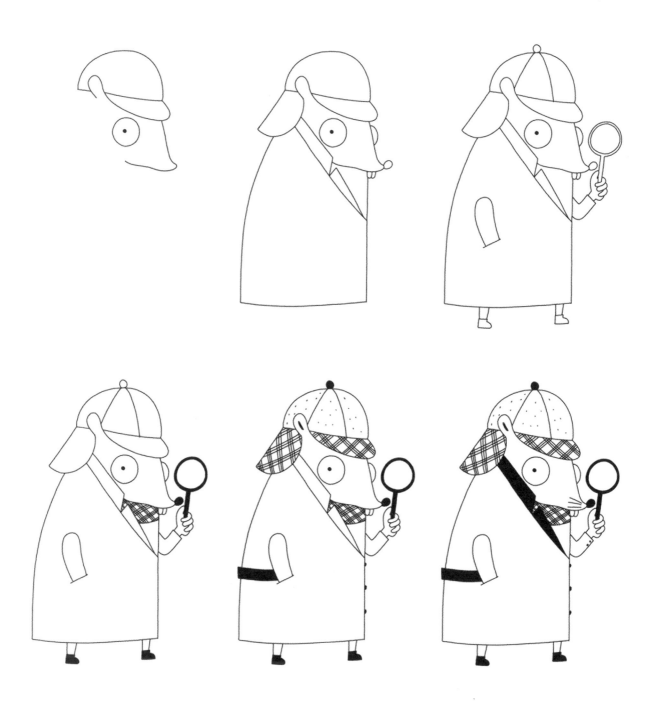

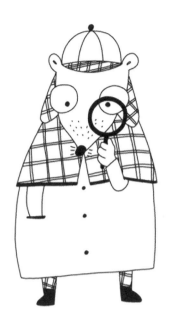

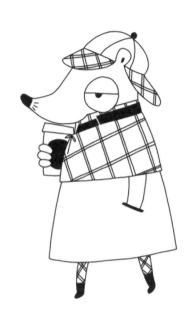

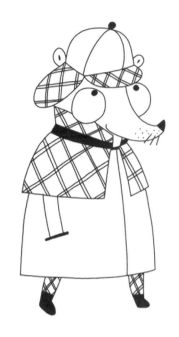

TRY IT!

Hmmm . . .

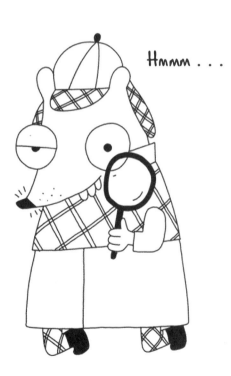

MAKE HIM CUTE

DRAW PATTY
THE PLATYPUS

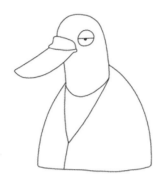
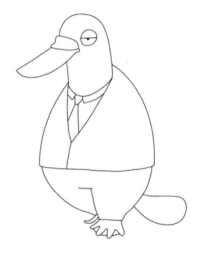
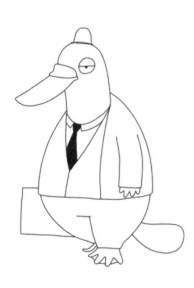
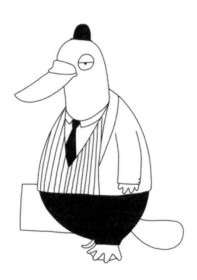
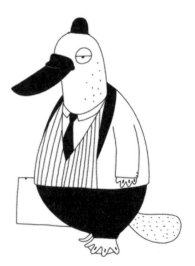

TRY IT!

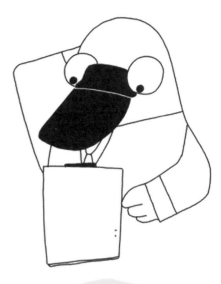

I'll lend you some money if . . .

LUNCH!
LUNCH!
LUNCH!

MAKE THEM CUTE

DRAW SWEETIE SALLY

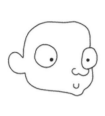
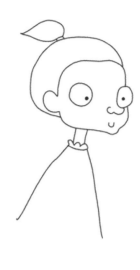
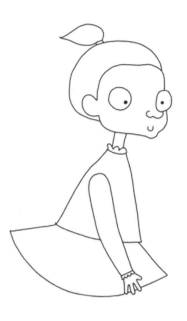

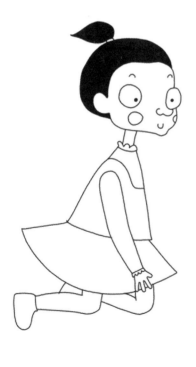
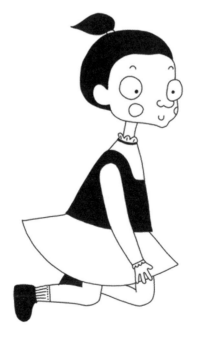
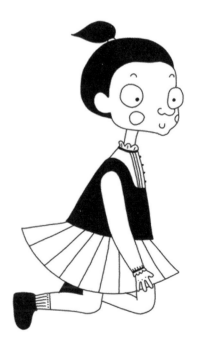

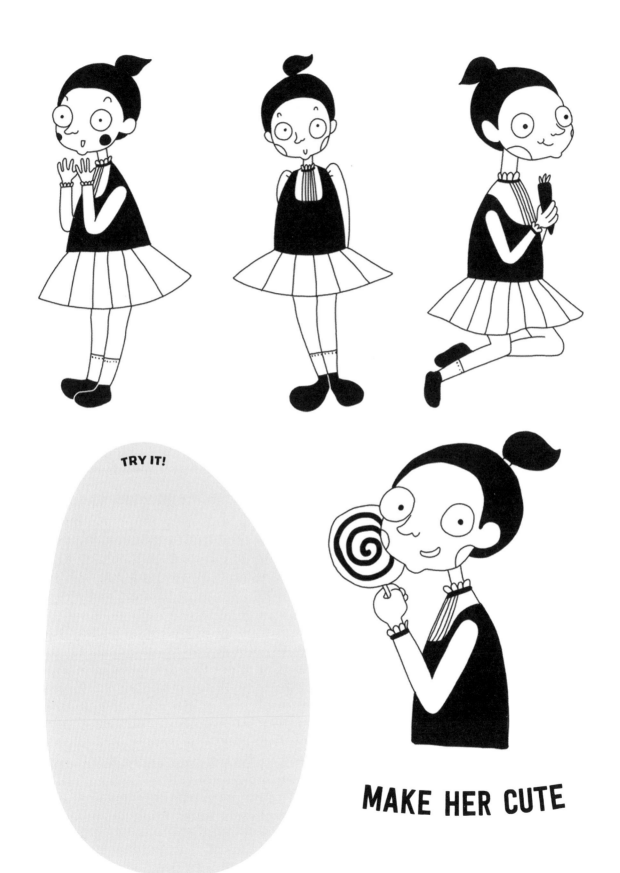

TRY IT!

MAKE HER CUTE

DRAW BARRY
THE BARISTA OWL

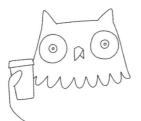
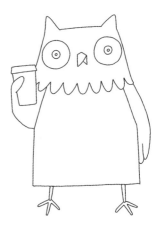

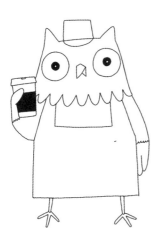
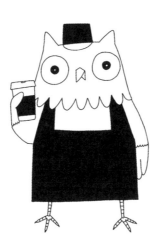
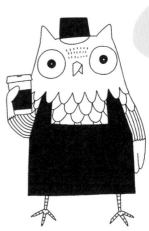

Who needs coffee?

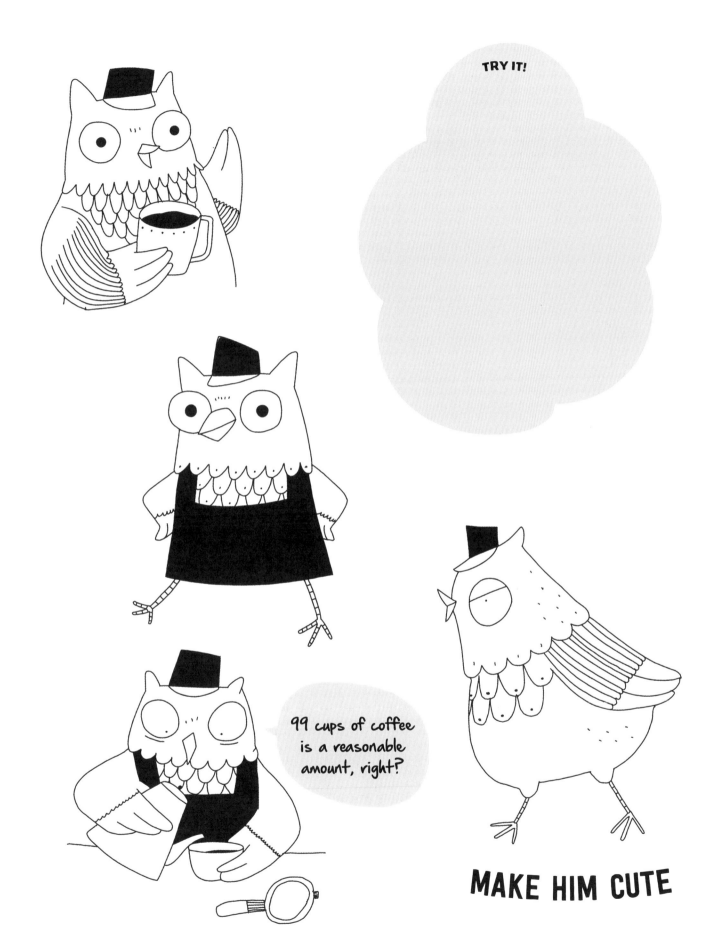

TRY IT!

99 cups of coffee
is a reasonable
amount, right?

MAKE HIM CUTE

DRAW MANNY
THE MAILMAN

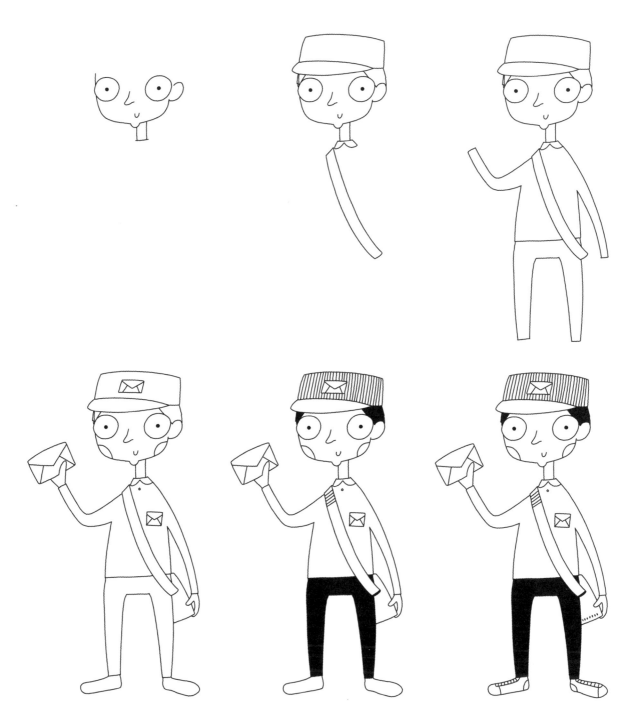

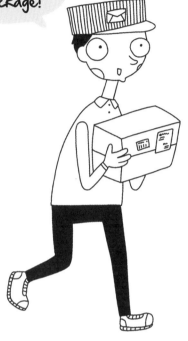

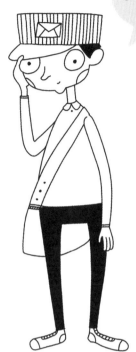

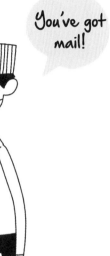

TRY IT!

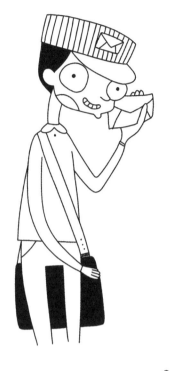

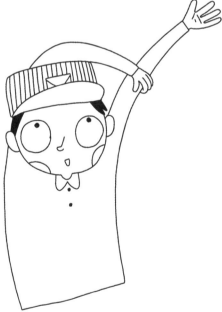

MAKE HIM CUTE

DRAW GARY
THE GHOST HUNTER

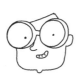

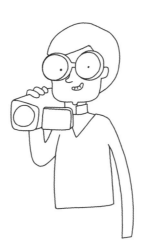

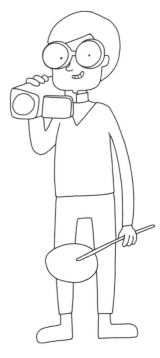

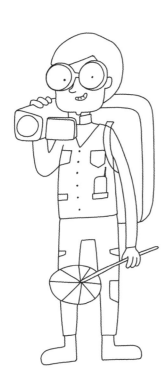

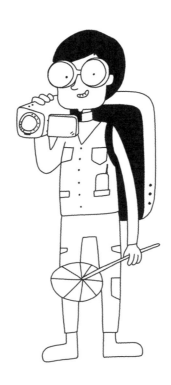

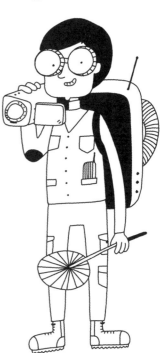

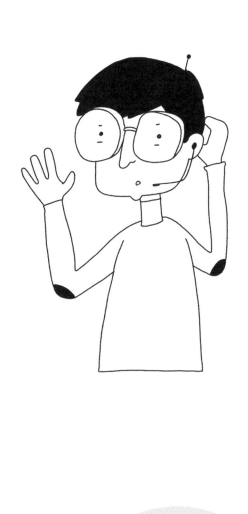

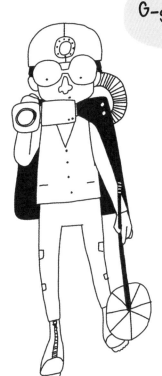

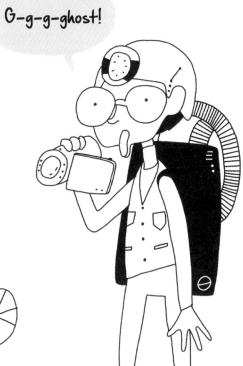

TRY IT!

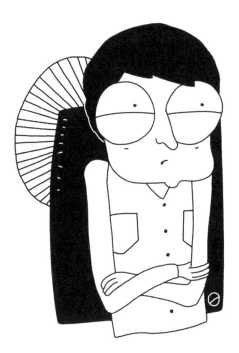

MAKE HIM CUTE

DRAW RAFAEL
THE ROBBER

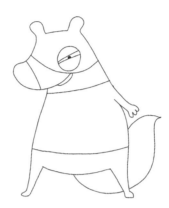
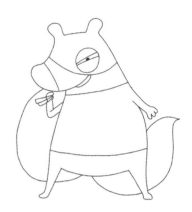

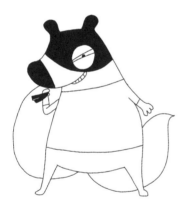
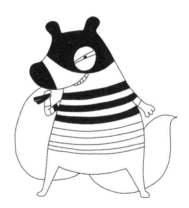
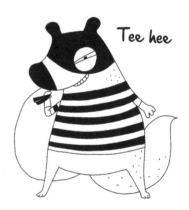

Tee hee

→**TIP**← Think about how you can vary the eyes of your character. Work on scrap paper to practice with different styles. Draw eyes with lids by adding a line partway across and draw a pupil in the lower half. Make eyes that look in a particular direction. Or make them squinty for a sneaky character like this one.

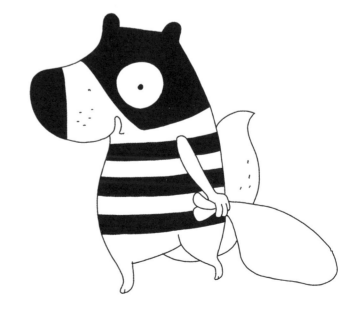

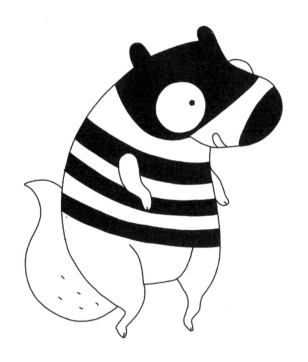

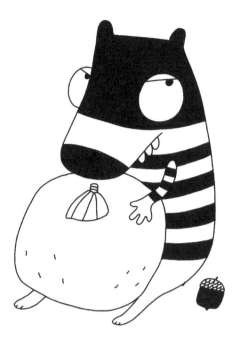

TRY IT!

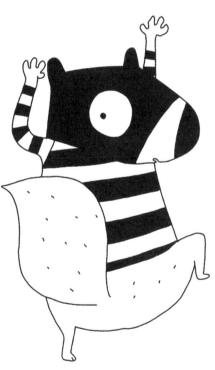

MAKE HIM CUTE

DRAW CHRIS CROC

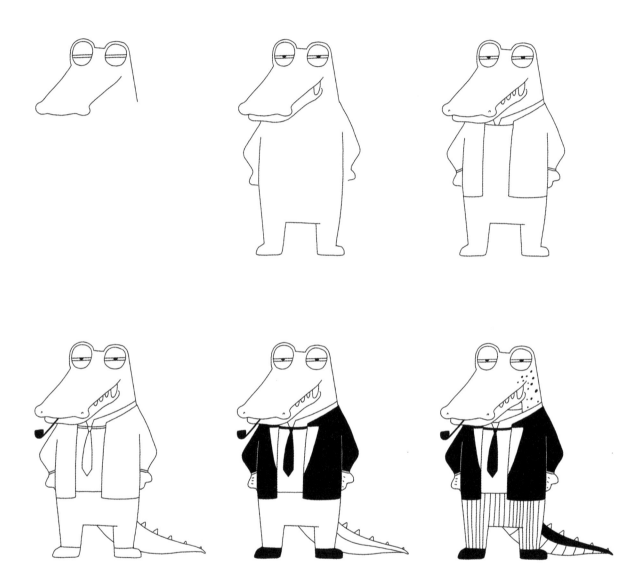

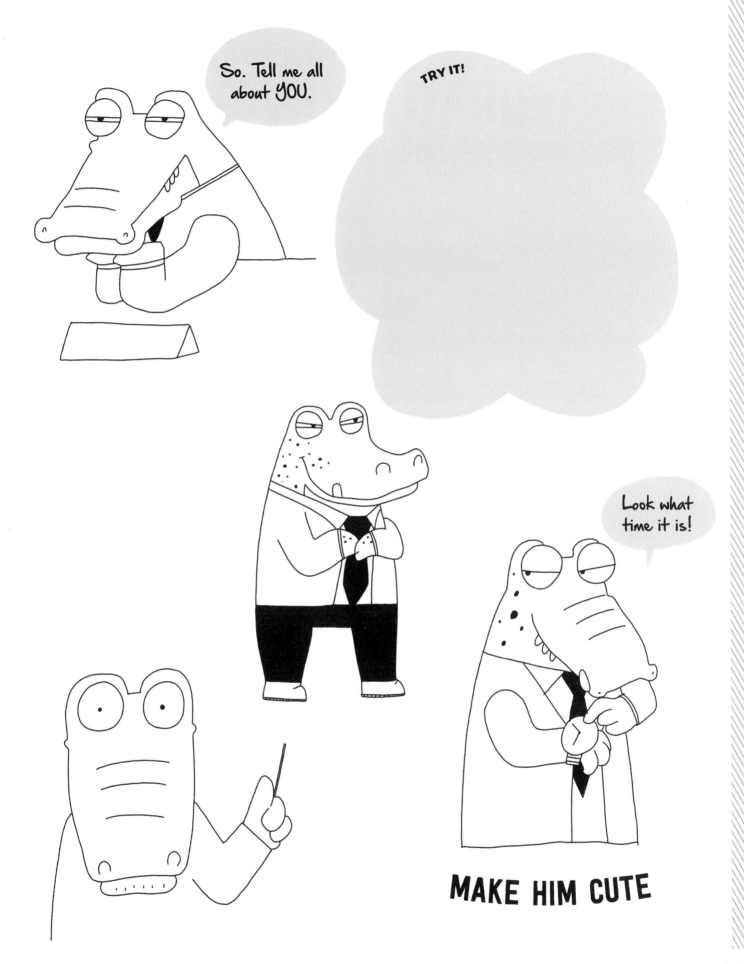

DRAW TREVOR
THE TURTLE

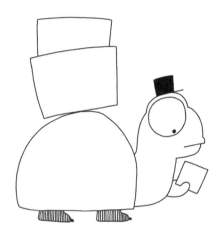
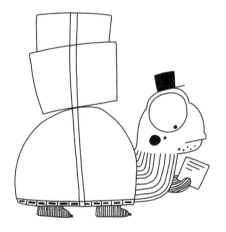

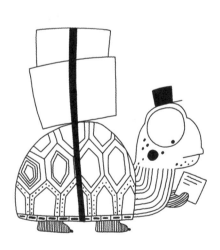
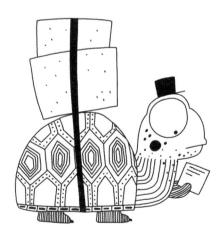

TRY IT!

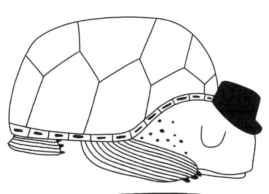

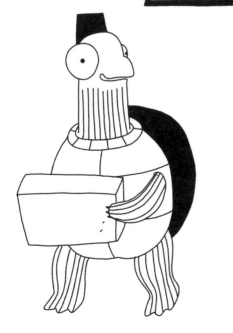

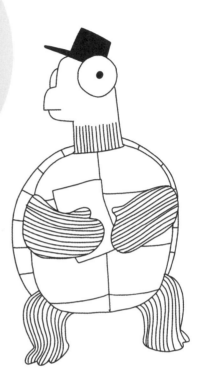

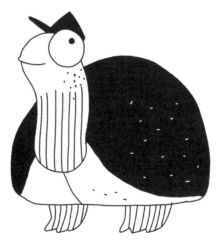

MAKE THEM CUTE

DRAW PRESS MASTER
POLLY POLAR BEAR

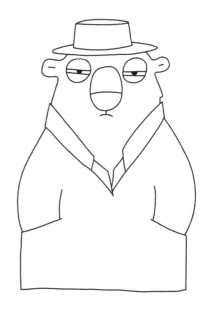

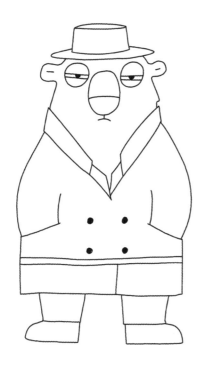

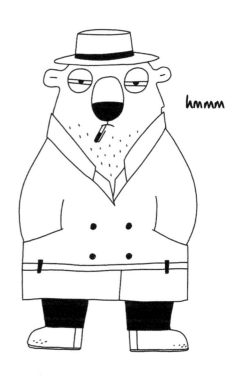

hmmm

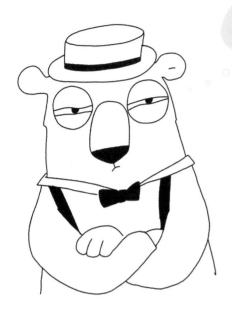

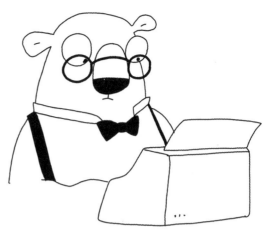

I smell something fishy . . .

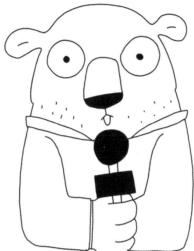

TRY IT!

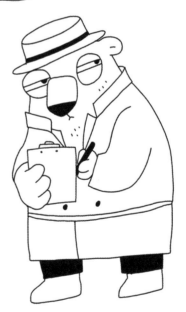

MAKE THEM CUTE

DRAW DEVI
THE DIAMOND JOKER

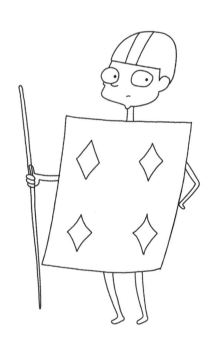

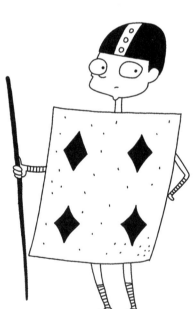

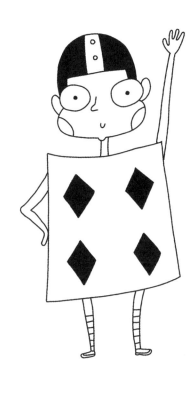

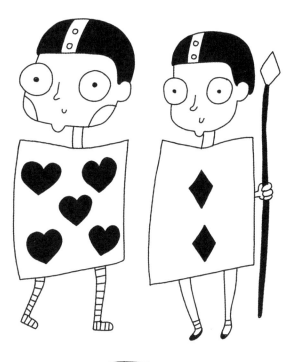

TRY IT!

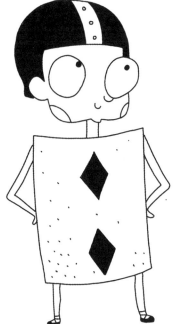

MAKE THEM CUTE

DRAW MARTY
THE MUSHROOM

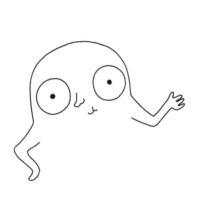

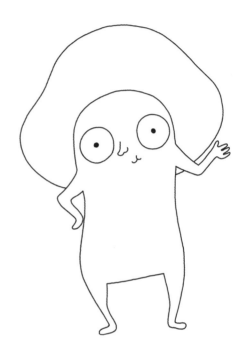

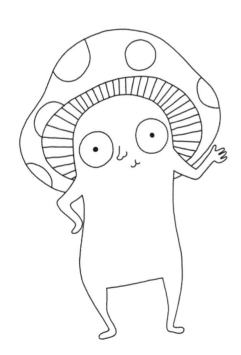

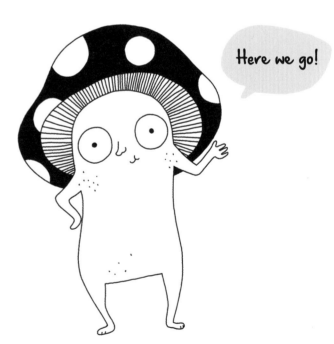

Here we go!

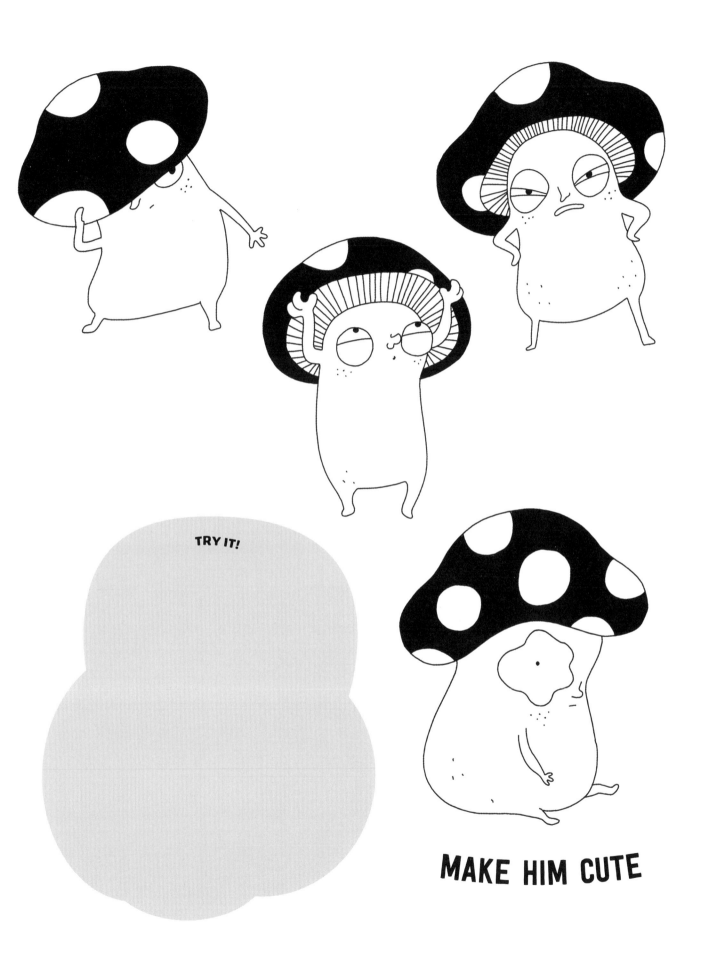

TRY IT!

MAKE HIM CUTE

DRAW CYRUS
THE CYCLOPS

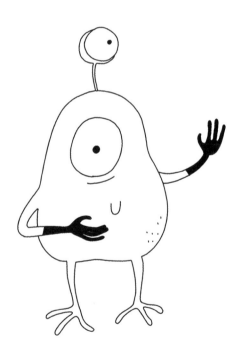

TRY IT!

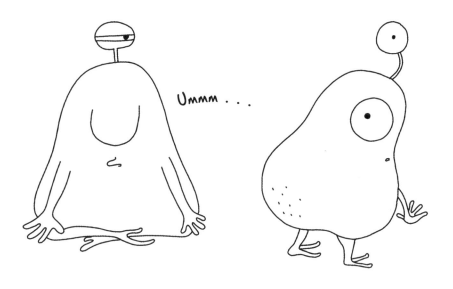

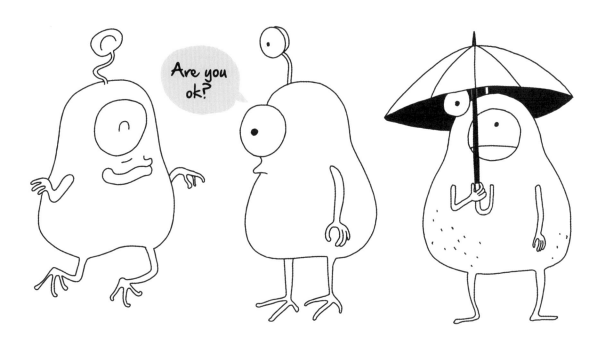

MAKE HIM CUTE

DRAW YOUNG-SOON
THE FLOWER PIXIE

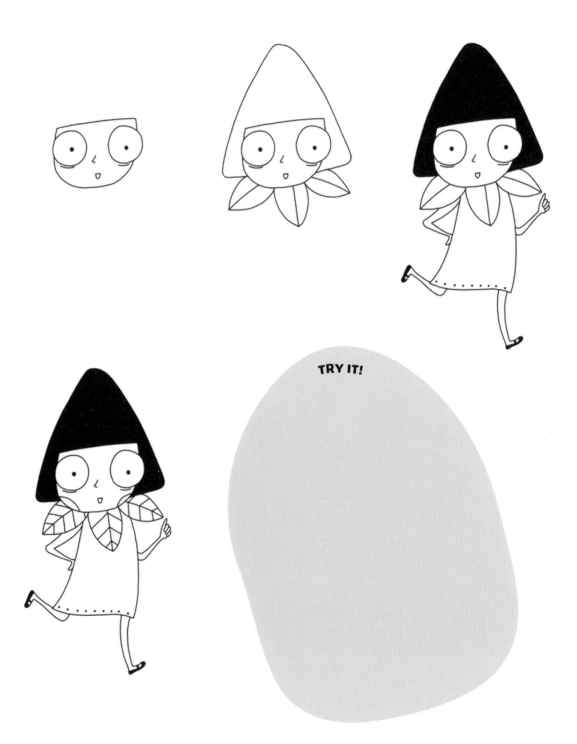

TRY IT!

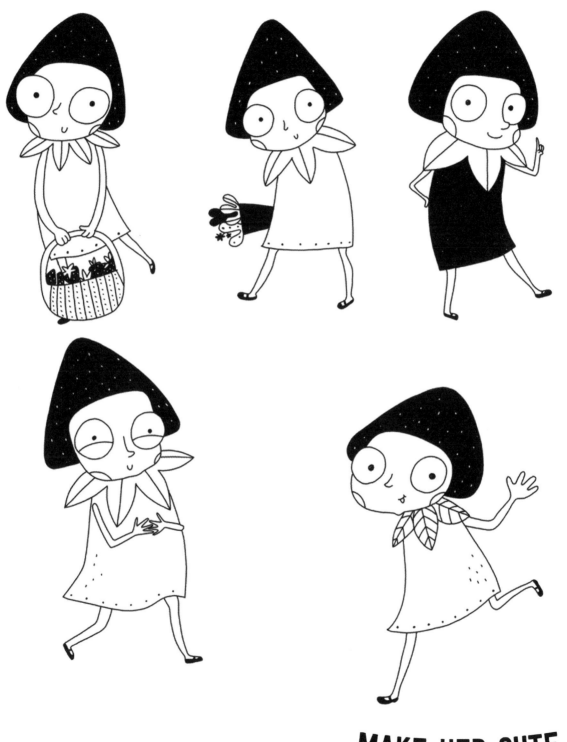

MAKE HER CUTE

DRAW JACK
THE JESTER

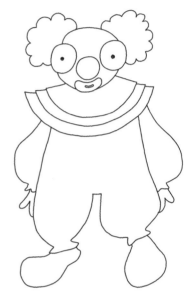

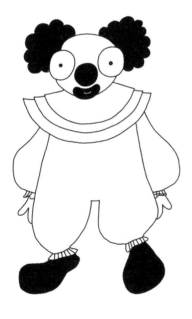
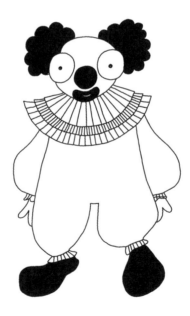
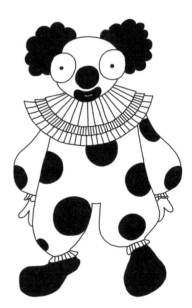

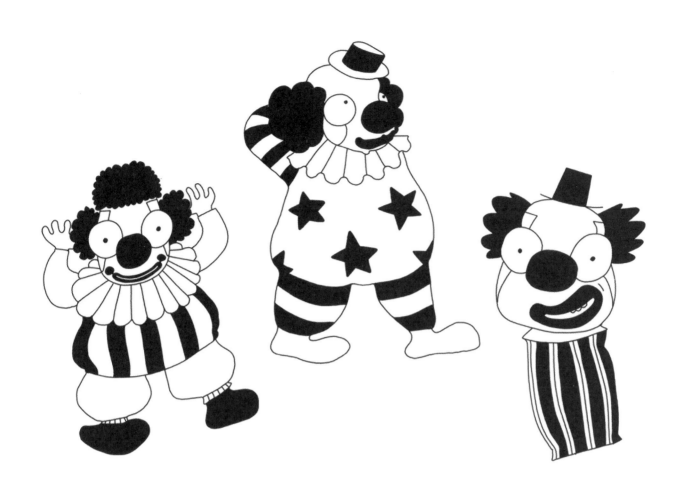

TRY IT!

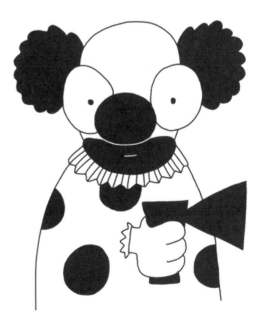

MAKE HIM CUTE

DRAW DEEP SEA DEXTER

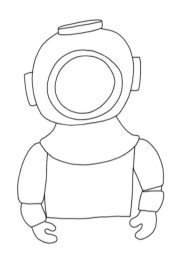

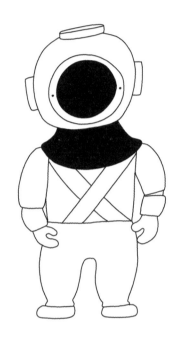

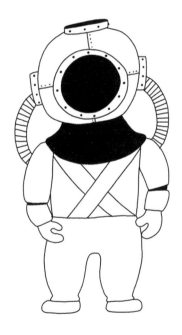

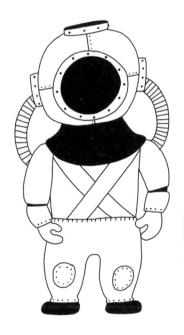

TRY IT!

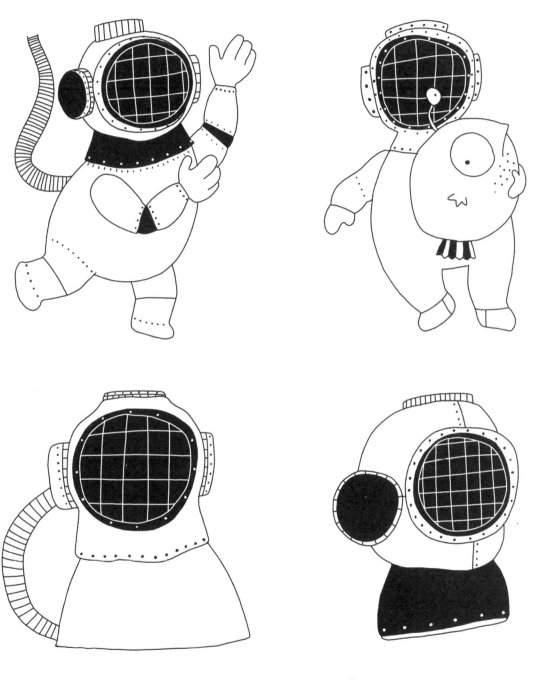

MAKE HIM CUTE

DRAW GRANNY GRETA

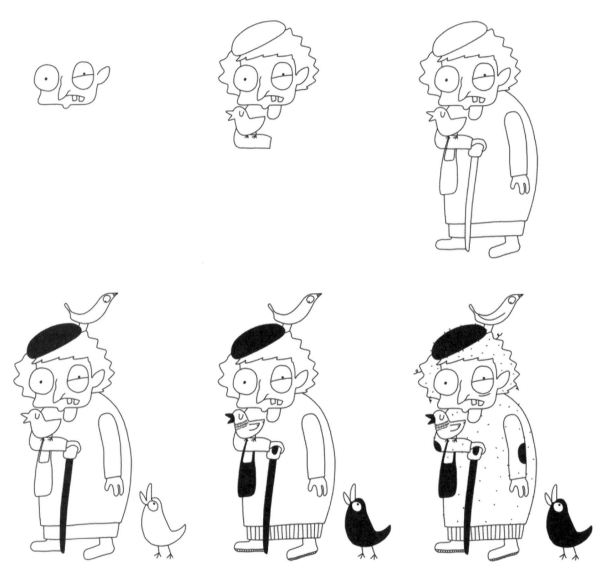

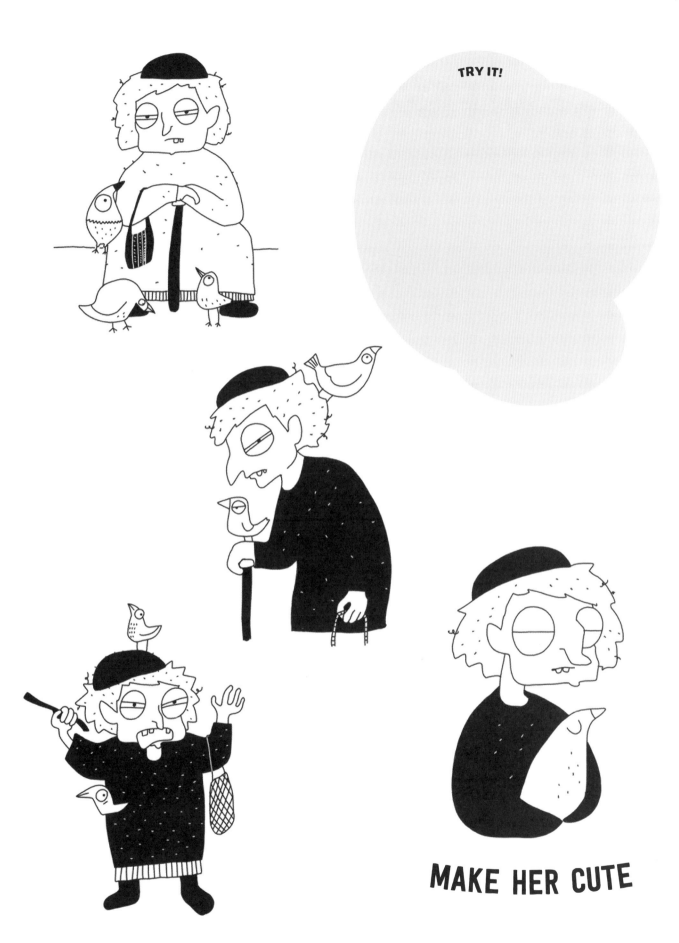

TRY IT!

MAKE HER CUTE

DRAW FARMER JEBEDIAH

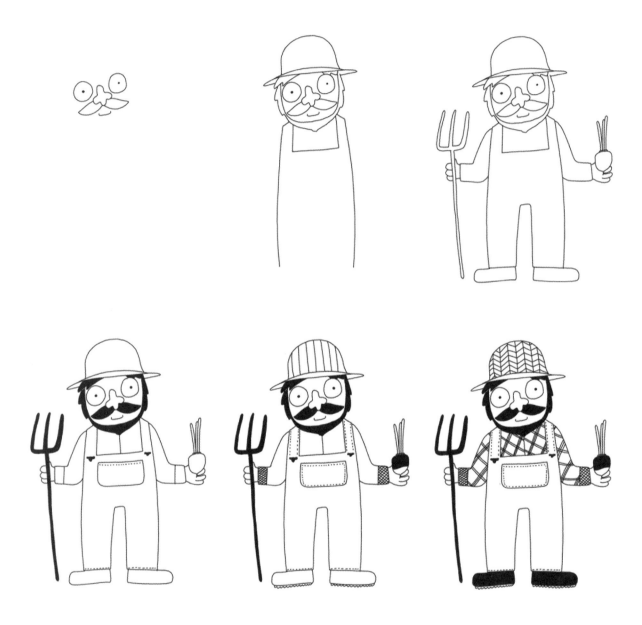

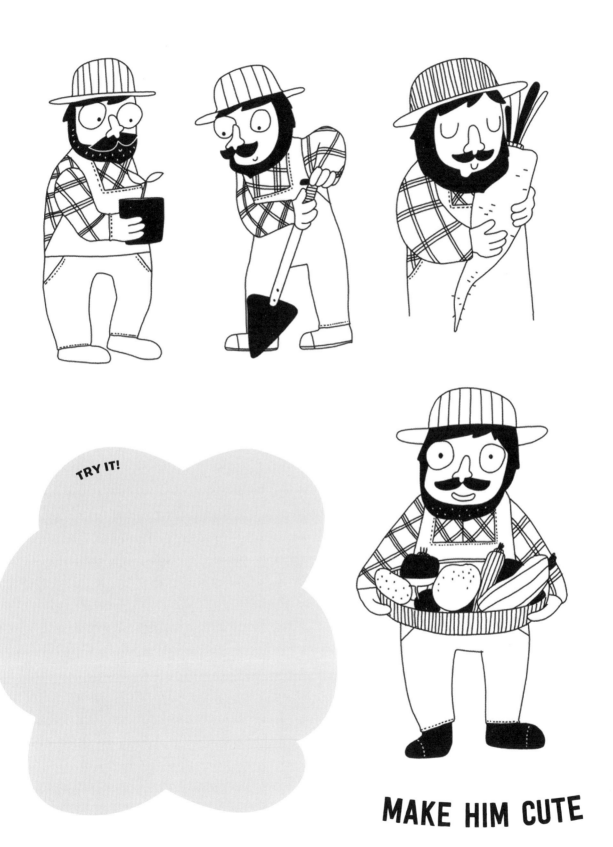

TRY IT!

MAKE HIM CUTE

DRAW LEX
THE LUMBER JACK

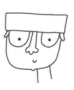
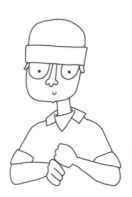
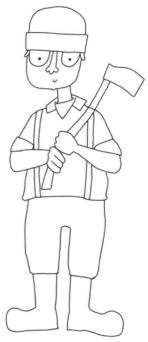

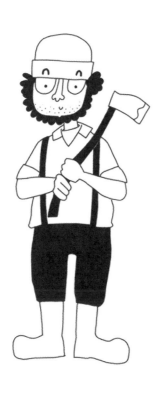
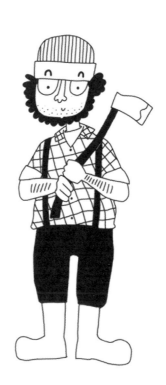
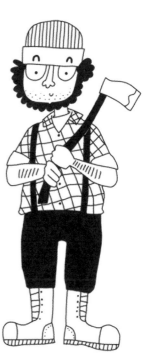

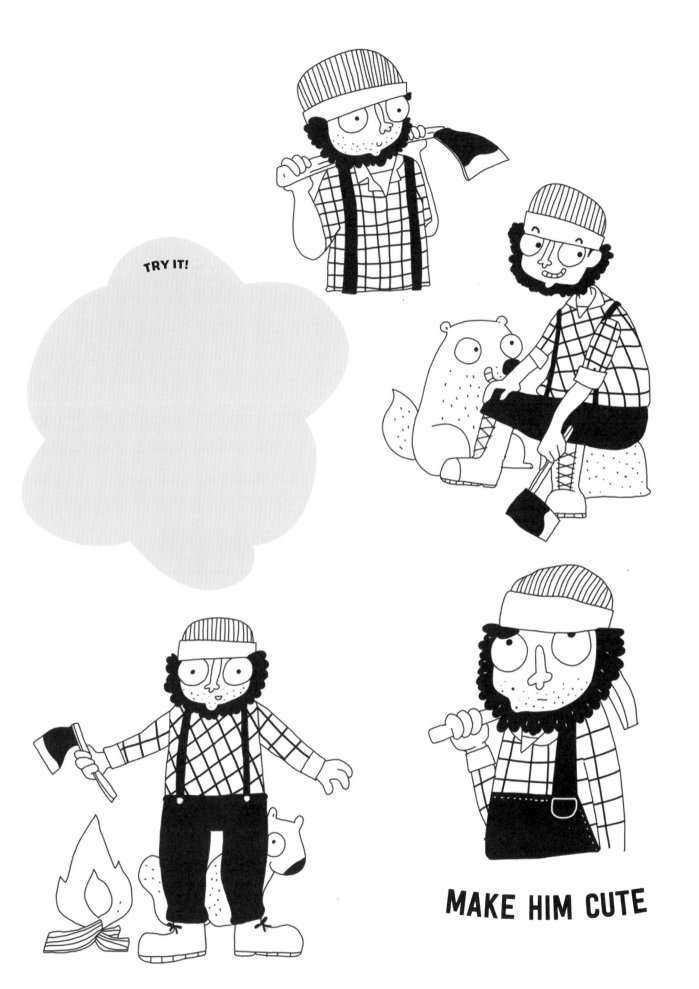

TRY IT!

MAKE HIM CUTE

DRAW TERRY
THE TOURIST

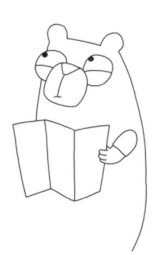

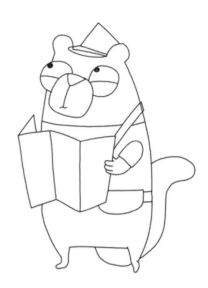

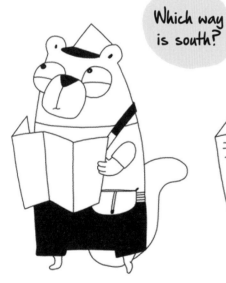

Which way is south?

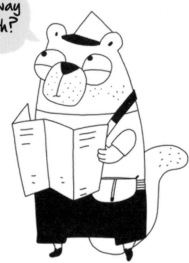

TRY IT!

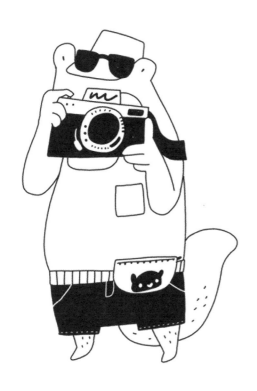

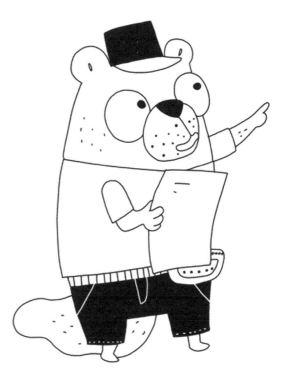

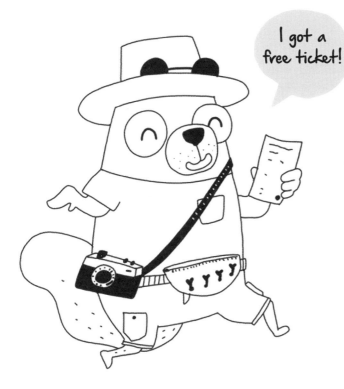

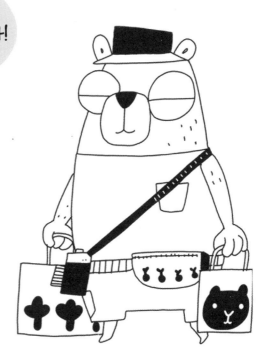

MAKE HIM CUTE

DRAW BUZZ
THE BODYGUARD

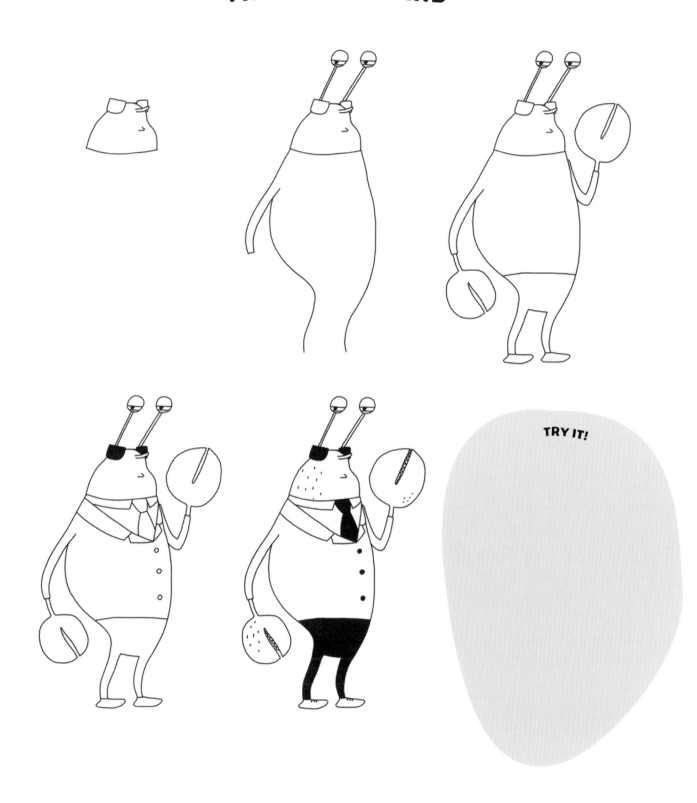

TRY IT!

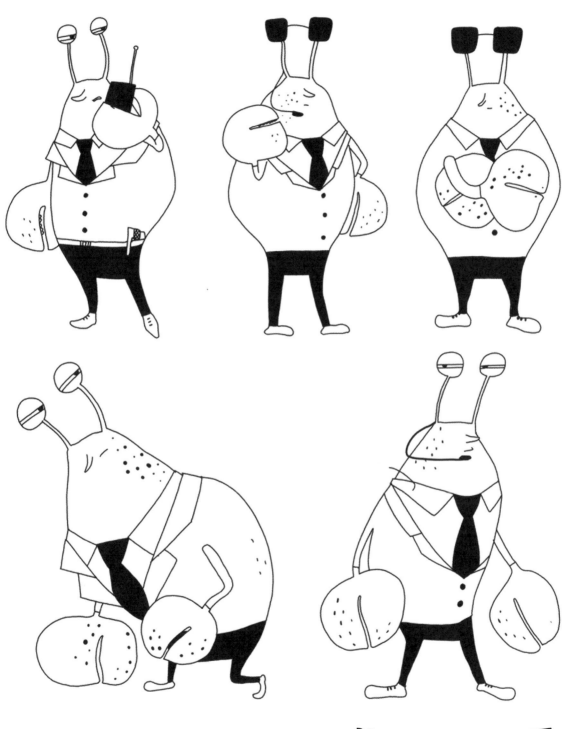

MAKE HIM CUTE

DRAW NALA KNIGHT

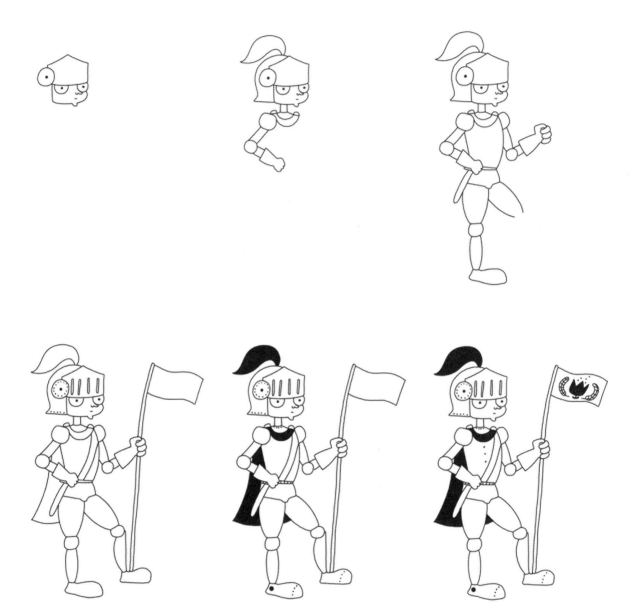

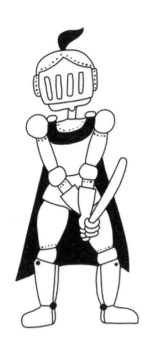

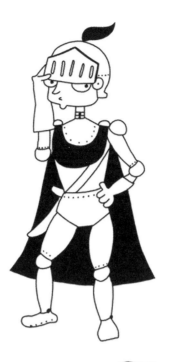

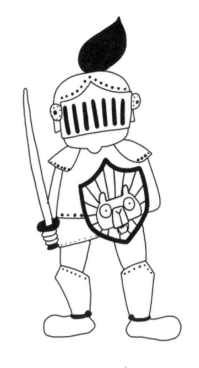

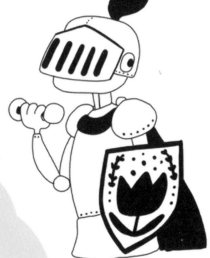

TRY IT!

MAKE HER CUTE

DRAW CRYSTAL CROW
THE FORTUNETELLER

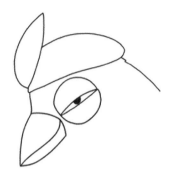

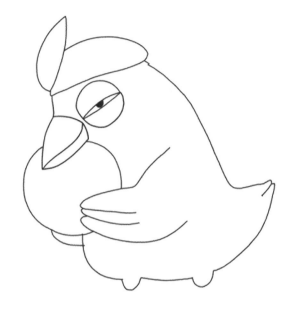

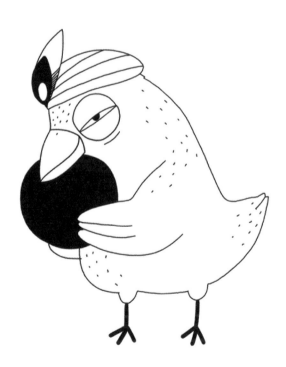

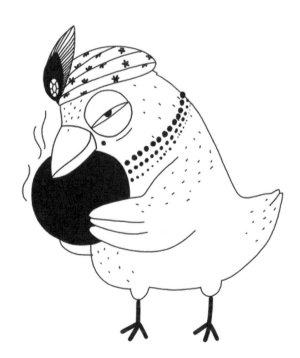

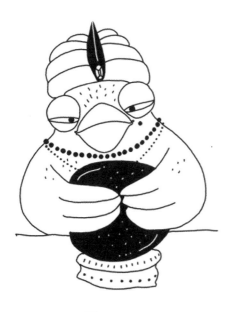

TRY IT!

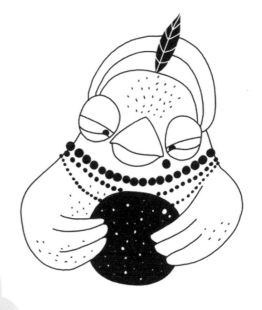

Oh my!
I gotta buy
a lottery
ticket today!

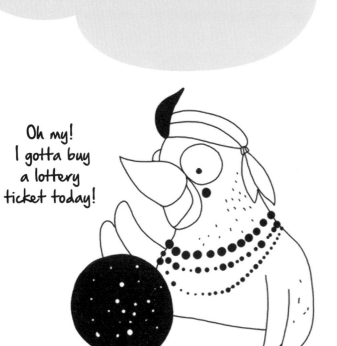

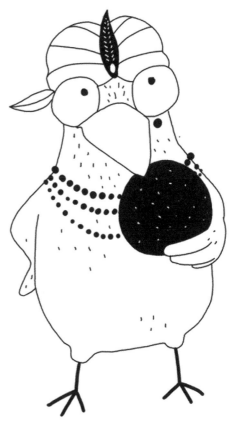

MAKE HER CUTE

DRAW ALVIN
THE ACCOUNTANT

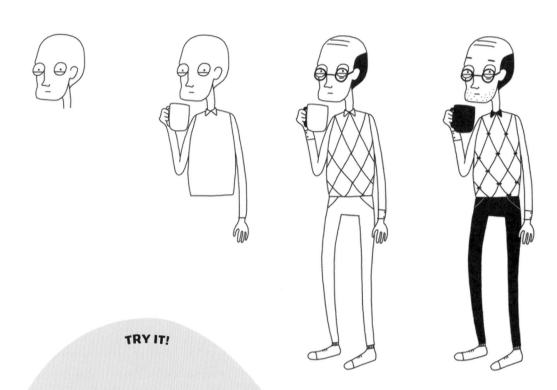

TRY IT!

→**TIP**← A signature garment is another way to solidify the look of a character. An argyle sweater implies a certain sort of preppiness . . . or at least aspirational preppiness.

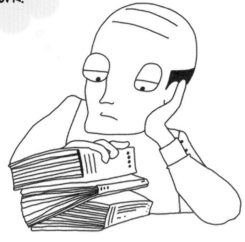

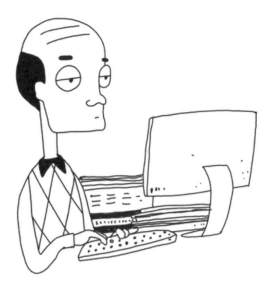

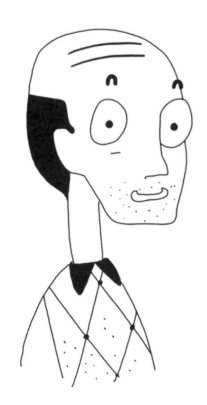

MAKE HIM CUTE

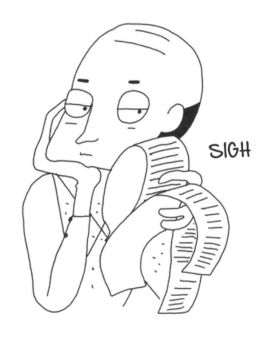

DRAW PADMA
THE PAWNBROKER

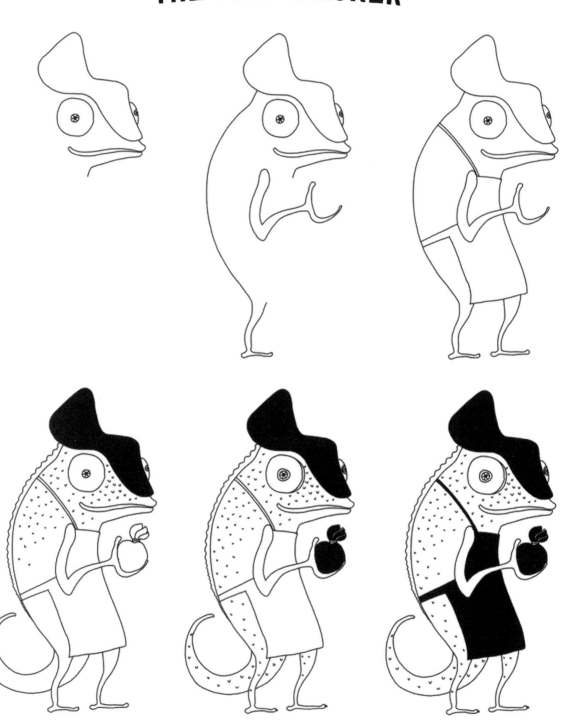

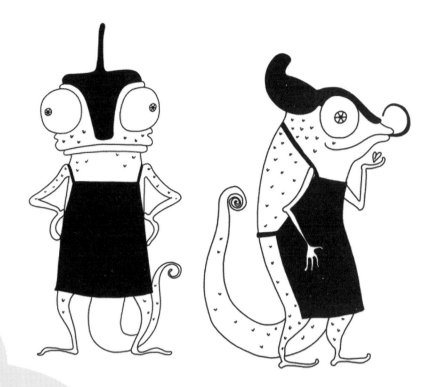

TRY IT!

Don't look!

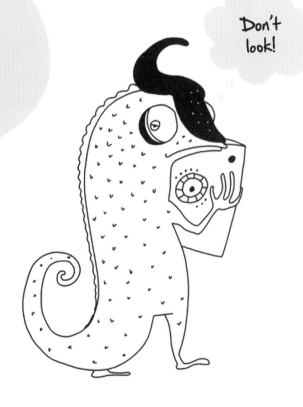

MAKE HER CUTE

DRAW SOZEN
THE SUSHI CHEF

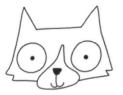
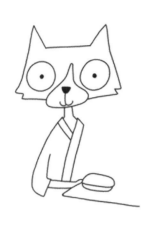
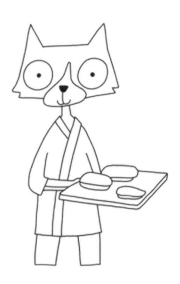

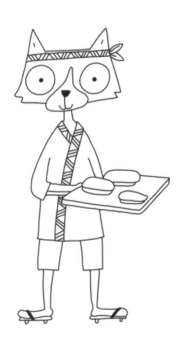
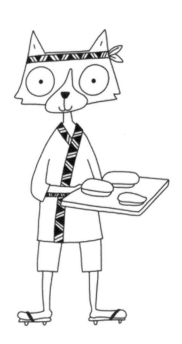
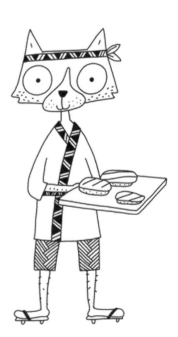

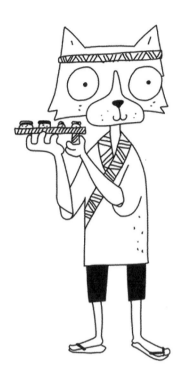

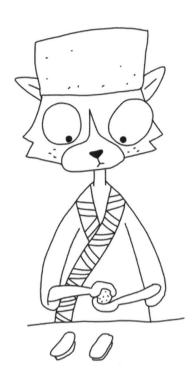

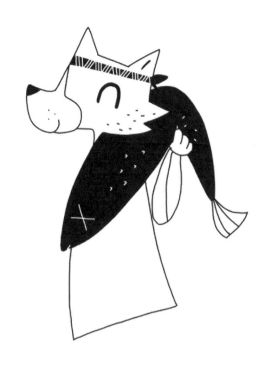

TRY IT!

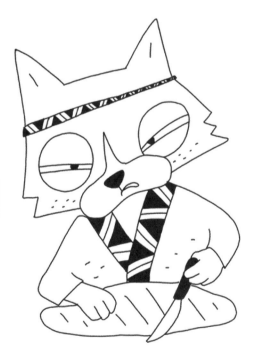

MAKE THEM CUTE

DRAW BRAD
THE BOOKWORM

 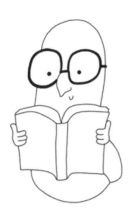 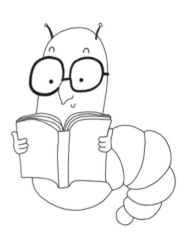

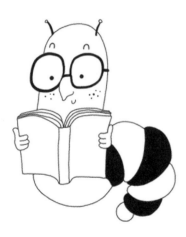 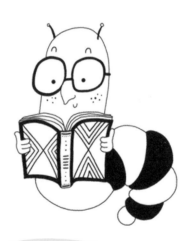 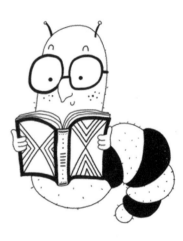

TRY IT!

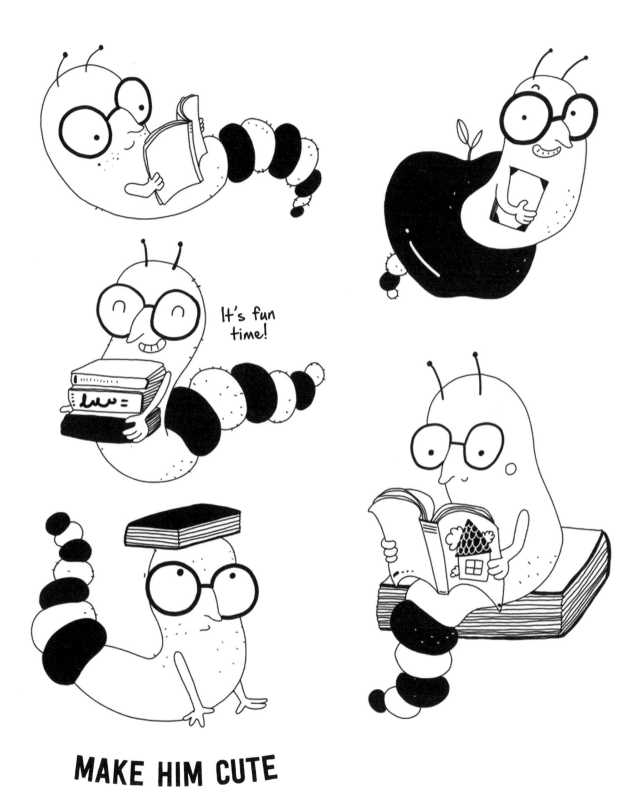

MAKE HIM CUTE

DRAW HUMPTY DUMPTY

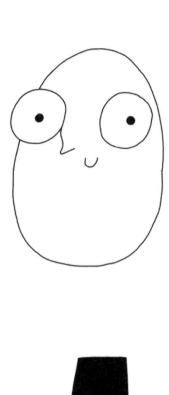
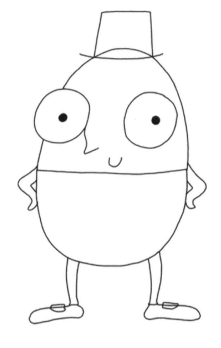
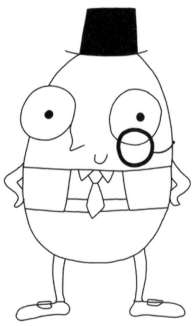
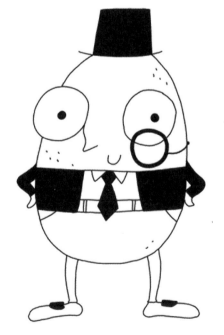

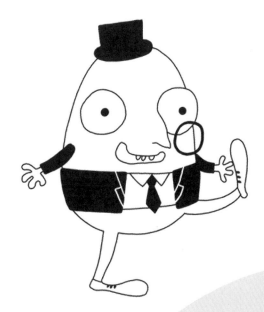

TRY IT!

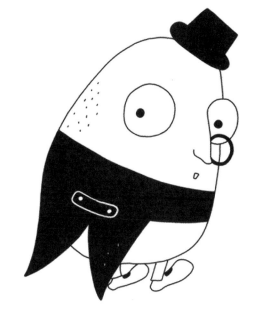

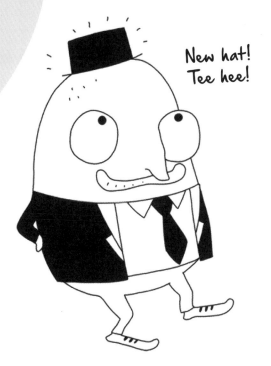

New hat!
Tee hee!

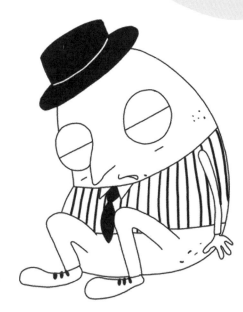

MAKE HIM CUTE

DRAW PLATO
THE PIRATE

 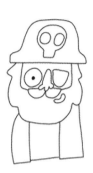 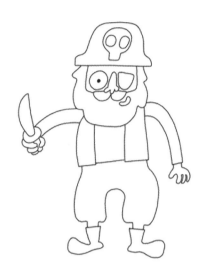

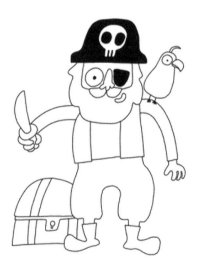 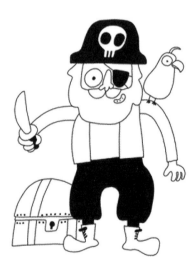 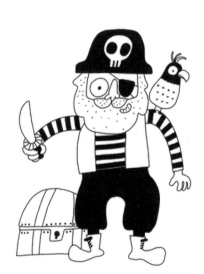

TRY IT!

Yar. Where did I bury me treasure?

MAKE HIM CUTE

DRAW FIONA FERN

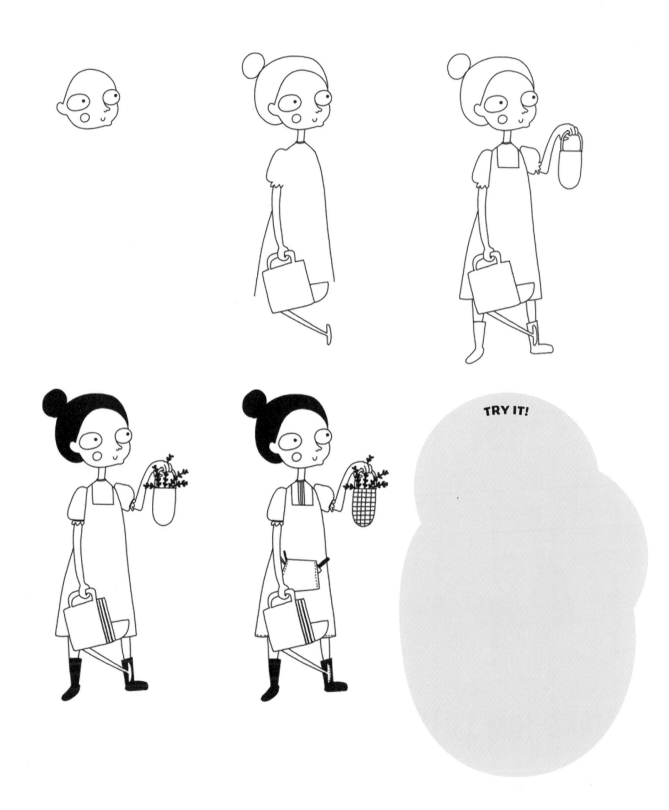

TRY IT!

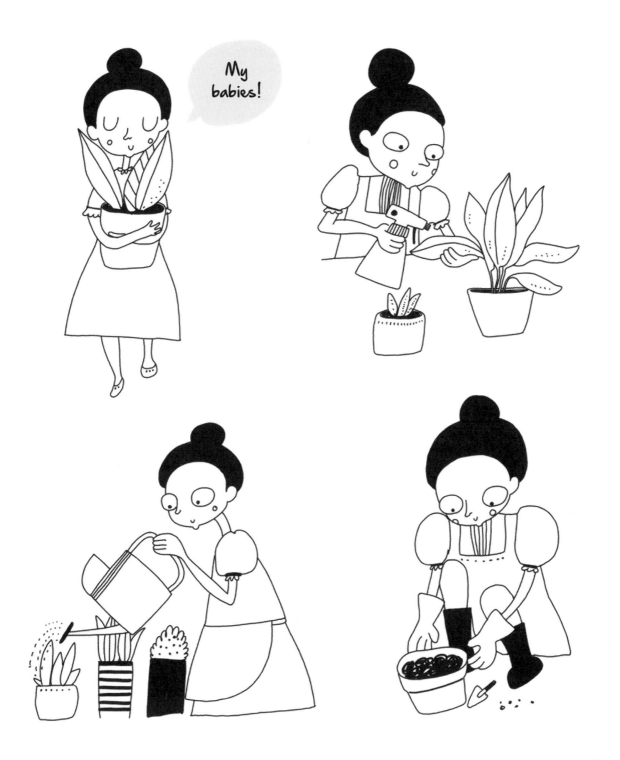

MAKE HER CUTE

ABOUT THE AUTHOR

Heegyum Kim is graphic designer and illustrator. She holds a master of science in communication design from Pratt Institute. She is the author and illustrator of *Draw 62 Animals and Make Them Cute* and *Draw 62 Magical Creatures and Make Them Cute*, the first two books in this series. She is the also author of two illustrated books featuring Mr. Fox, the charming and humorous character whose activities and musings drive her popular Instagram account and make her followers giggle, as do a menagerie of other delightful animal friends. She lives in Jersey City, New Jersey. Follow her drawing adventures on Instagram: www.instagram.com/hee_cookingdiary.

Brimming with creative inspiration, how-to projects, and useful information to enrich your everyday life, Quarto Knows is a favorite destination for those pursuing their interests and passions. Visit our site and dig deeper with our books into your area of interest: Quarto Creates, Quarto Cooks, Quarto Homes, Quarto Lives, Quarto Drives, Quarto Explores, Quarto Gifts, or Quarto Kids.

First Published in 2020 by Quarry Books, an imprint of The Quarto Group, 100 Cummings Center, Suite 265-D, Beverly, MA 01915, USA.
T (978) 282-9590 F (978) 283-2742 QuartoKnows.com

Quarry Books titles are also available at discount for retail, wholesale, promotional, and bulk purchase. For details, contact the Special Sales Manager by email at specialsales@quarto.com or by mail at The Quarto Group, Attn: Special Sales Manager, 100 Cummings Center, Suite 265-D, Beverly, MA 01915, USA.

10 9 8 7 6 5 4 3 2 1

ISBN: 978-1-63159-821-0

Digital edition published in 2020
eISBN: 978-1-61359-822-7

Library of Congress Control Number: 2019947074

Design: Debbie Berne

Printed in China

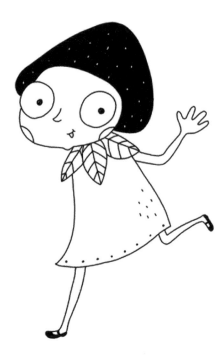